IMAGES
of America

BURLINGTON

1956 -1970

850 Rogers Rd
Burlington
Ky
41005
5866707

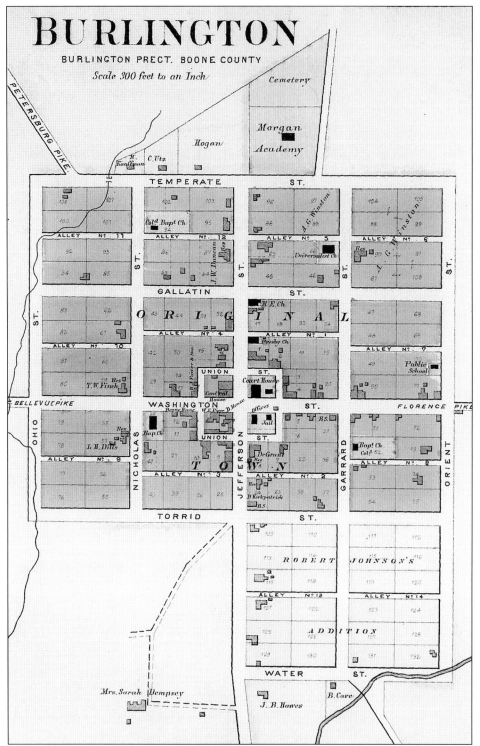

This is the earliest legible map of Burlington and is from D.J. Lake & Co.'s 1883 *Atlas of Boone, Kenton, and Campbell Counties, Kentucky.*

IMAGES
of America

BURLINGTON

Matthew E. Becher, Michael D. Rouse,
Robert Schrage, and Laurie Wilcox

ARCADIA

Published by Arcadia Publishing
Charleston SC, Chicago IL, Portsmouth NH, San Francisco CA

Printed in Great Britain

Library of Congress Catalog Card Number: 2004108897

For all general information contact Arcadia Publishing at:
Telephone 843-853-2070
Fax 843-853-0044
E-mail sales@arcadiapublishing.com
For customer service and orders:
Toll-Free 1-888-313-2665

Visit us on the internet at http://www.arcadiapublishing.com

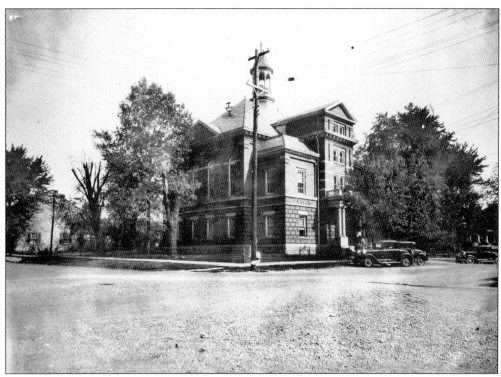

This photograph shows the 1889 Boone County courthouse as it appeared about 1930. Located on the corner of Washington and Jefferson Streets in the heart of Burlington, the 1889 building is the third to occupy this prominent site. The courthouse was always the center of activity in Burlington. According to an article in a 1911 issue of the *Boone County Recorder*, "County Court days were gala days, with persons, both men and women, coming from all parts of the county to meet and greet each other."

CONTENTS

ACKNOWLEDGMENTS

No work encompassing 200 years of the history of a community such as Burlington could be completed without the assistance of a great number of individuals and organizations. The authors wish to express their gratitude to the following people and organizations who assisted in the gathering of photographs or any other information used in the book: David Beasley, Boone County Conservation District, Boone County Cooperative Extension Service, Boone County Planning Commission, Boone County Public Library, Bartley Brown, Burlington Baptist Church, Susan Cabot, John Caldwell, Cincinnati Bell Telephone, *Cincinnati Enquirer*, *Cincinnati Post*, Joseph Lucas Claxon III, Alvin Clore, Catherine T. Collope, Mary Kathryn Dickerson (Conservation District), Dinsmore Homestead Foundation, Terri Rice Disque, Harold L. Dringenburg, Bruce Ferguson, Doratha A. Griesser, Gary Griesser, Mary Lou Holbrook, Robert Jonas, Arlene Jones, Kenton County Public Library, Elizabeth Kirtley, Betsy Maurer Ligon, Diane Mason, Margaret Maurer, Robert Maurer, William McBee, Marty McDonald, Dr. Carol Milburn Swartz, Northern Kentucky Area Development District, Jeanetta Oaks, Betty Poole, Katie Presnell, Edward Prindle (Boone County jailer,) Carroll "Buddy" Rice, Polly Schadler, Pat Scott, Bernie Spencer and Northern Kentucky Views, Melanie Sperling, Tom Utz, Carolyn Van Huss (nee Cropper), Robert Walton, Margaret Warminski, Glenrose Williams, and Harold Williams.

A special thanks goes to the Boone County Historic Preservation Review Board, which sponsored the book and is the project's official representative. Members of the board at the time of publication were, Patricia Fox (chair), Donald E. Clare (vice-chair), Ted Bushelman, Sharon Elliston, Mike Moreland, Robert Schrage, and Bridget Striker.

INTRODUCTION

As the seat of government for Boone County, Kentucky, Burlington was planned as a capital city. In 1799, the county court of newly formed Boone County chose to locate the seat of government in the north-central part of the county on 74 acres of land donated by Robert Johnson and John Hawkins Craig. The town was first known as Craig's Camp and then called Wilmington. It was renamed Burlington in 1816 at the request of the post office. Burlington was incorporated in 1824; however, the corporation was annulled in 1923, and Burlington remains unincorporated today.

Burlington's town plat, drawn c. 1805 by county surveyor Moses Scott, remains the most striking example of formal town planning in northern Kentucky. The plan originally called for 12 squares grouped around the intersection of the two principal roads, with a central "Publick Square." The town plan was later modified to allow the two principal roads, Washington Street (Burlington Pike) and Jefferson Street (Idlewild/East Bend Road) to cross the square rather than travel around it. The central square was divided into four rectangular plots. The courthouse has always occupied the northeast plot, while the Clerk's Building and jail occupied the southeast plot. The two western plots were sold off for commercial development.

From 1799 to 1801, county functions were held at homes in and around the county seat. The county's first log courthouse was completed by January 1801. Its presence is noted in the *County Order Book*, which simply states that "Court [was] held for the County of Boone at the Courthouse." In 1817, the building was replaced by a large brick structure facing Jefferson Street. In 1833, the first brick jail was built. It was replaced by a more substantial brick jail in 1853. Also in 1853, the county constructed a Greek Revival temple-front building to house the office of the county clerk. The 1817 courthouse was remodeled several times and finally demolished in 1889 when a new courthouse was built. It was designed by the Louisville architectural firm McDonald Brothers, architects of numerous courthouses in Kentucky and Indiana in the 1890s. The present courthouse cupola was designed in 1898 by the renowned Cincinnati architectural firm, Samual Hannaford and Sons.

Some of Burlington's quaint street names reflect geographical orientation: Temperate Street forms the north side of the town plan; Torrid Street borders the south; and Orient Street borders the east. Other streets were named after founding fathers such as George Washington and Thomas Jefferson, or Kentucky politicians like Garrard, Gallatin, and Nicholson. The town's layout and the placement of the buildings show its founders' great expectations: most of the early houses are built at or close to the street, in an urban fashion.

By 1840, stylish brick houses, taverns, and commercial buildings began to crowd the center of town. The Central House Hotel (now the County Seat Restaurant) stood opposite the courthouse at the corner of Jefferson and Washington Streets. The Boone House Hotel (now known as the Renaker House) on Union Square was a tavern and inn from c. 1830 to c. 1870. Along Jefferson Street stood stately brick residences in the Federal and Greek Revival styles, some of which were used as commercial buildings at various times in their history. One of the finest of these homes is the c. 1822 Erastus Tousey House, a brick Federal residence that recently opened as the Tousey House Restaurant.

By 1850, Burlington had 200 residents, as well as stores, taverns, three hotels, and a wool factory. Four types of churches served the faithful: Baptist, Methodist, Presbyterian, and Universalist. Two African-American Baptist congregations were formed after the Civil War. Turnpikes led to Florence and later to the bustling river town of Petersburg.

Two newspapers have operated out of Burlington. The first was the *Burlington Advertiser*, a weekly paper founded in 1849 by W.H. Nelson. The paper was published for just one year. In 1875, the *Boone County Recorder* began publication in Burlington as a weekly paper; the *Recorder* continues to operate today. An 1880 letter to the *Recorder*, written by a visitor from nearby Grant County, made some amusing observations of the rural county seat of Boone County:

> Burlington is a dull, sleepy, town of about two or three hundred inhabitants. . . . It has no bank, no livery stable, no barber shop, a lady is seldom seen on the street. . . . Not withstanding the Rip Van Winkle sleep into which this ancient town seems to have fallen, her citizens are noted for their courtesy and hospitality, especially the bar and county officials; in fact Boone County is blessed with good officers.

Burlington may have been a "Rip Van Winkle" town, but countless unique individuals quietly left their mark on this hard-working farming community. Their stories enrich the history of Burlington more than any of the town's historic buildings. Most visible of those who shaped today's Burlington were Boone County judge-executives such as Nathaniel E. Riddell, Carroll C. Cropper, and Bruce Ferguson. In 1943, Sheriff J.T. "Jake" Williams investigated the notorious Kiger murder case. Following his sudden death the following year, daughter Glenrose Williams was appointed sheriff, becoming the first woman in Kentucky to hold the office. Burlington was also home to well-known artist Caroline Williams and ladies professional baseball player Patricia Scott.

Peaceful Burlington also attracted several noted inventors. Dr. George Sperti, inventor of the sunlamp and topical ointments, owned a large experimental farm just south of town, where he raised everything from white laboratory mice to national champion bulls. A few miles to the west, Thomas Zane Roberts created unique household labor-saving devices and a monumental celestial clock. The least well-known Burlington inventor left the most enduring legacy. Dubbed the "Cornfield Edison," Frank S. Milburn photographed everyday life in Burlington, helped to modernize local telephone service, drew thousands of promising inventors to this quiet county seat, and secretly aided America's victory in World War II.

Most of the images presented in *Images of America: Burlington*, were taken between about 1890 and 1980. Burlington changed very little over those decades, continuing to function as the miniature capital city of a largely rural county. Burlington now lies at the heart of one of the fastest growing counties in the nation, but many of the elements that make it such a perfect example of a rural county seat are still evident today. The authors sincerely hope this volume adequately portrays this little county seat that so many love and call home.

One
INSTITUTIONS
Government, Agencies,
and Organizations

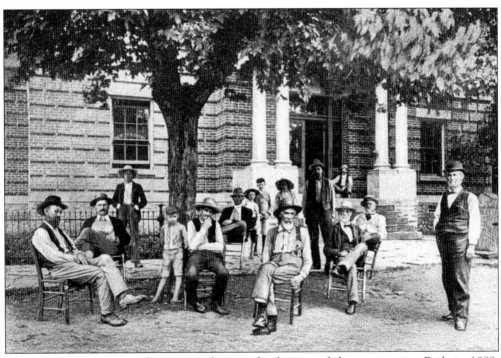

The Boone County Courthouse was always a focal point of the community. Built in 1889, virtually all of Boone County's government and legal business took place there until a new Administration Building was completed in 1981. This picture was taken by Mrs. John Uri Lloyd and published in 1900 in John Uri Lloyd's *Stringtown on the Pike: a Tale of Northernmost Kentucky*, with the caption "I bade by all my Stringtown friends good-bye."

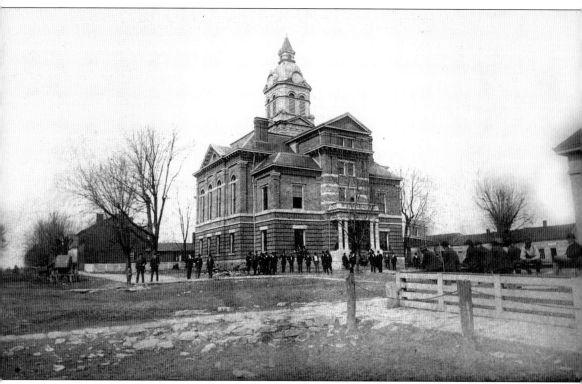

This *c.* 1890 photograph is the earliest-known image of the present Boone County Courthouse, the third to occupy the same site. Built for $19,740 in 1889, the structure was designed by the McDonald Brothers (a Louisville architectural firm) and erected by the McGarvey Brothers (a Cincinnati contractor). The courthouse is a Renaissance Revival brick edifice, cruciform in plan, with subsidiary blocks in the four angles. The exterior walls are articulated by pilasters and a deep cornice, and rusticated brickwork lends depth and visual interest. A lower brick wing was added to the east elevation about 1960. During the 1880s, the McDonald Brothers designed numerous Kentucky courthouses with similar floor plans. By varying details such as building as steeple size, number of windows, and type of exterior wall finish, the firm was able to furnish designs for courthouses ranging in cost from about $20,000 to nearly $80,000.

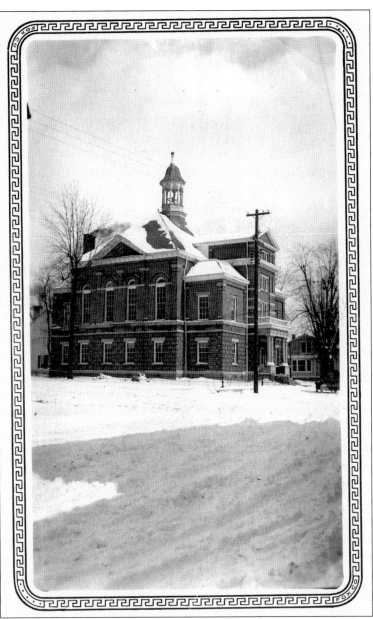

This 1932 snow scene postcard shows the courthouse as it has appeared since 1898, when the original dome was replaced with a much smaller cupola. The cupola was designed by prolific Cincinnati architects Samual Hannaford & Sons, who designed both Cincinnati City Hall and Cincinnati's Music Hall. The massive wood truss system supporting the original dome remains in the building, but virtually everything above that point was cut out and replaced. The alteration was costly and frustrating for the county, which paid nearly $20,000 for the building only 9 years before. The reasons for the alteration are clear: the weight of the dome was pushing the walls of the building apart. A 1902 article in the *Boone County Recorder* notes, "The inside walls of the court house are shisters [sic] of the worst kind. . . . The man who was paid to superintend the construction of the building either did not understand his business or was a fraud."

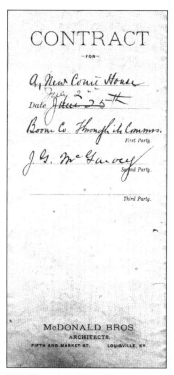

This signed copy of Boone County's contract with the McDonald Brothers (architects of the 1889 courthouse) is one of several known pieces of original correspondence relating to the courthouse. In one letter from the McDonald Brothers, they comment on the fact that the contractor used bricks of differing colors in the first and second stories. This difference is still visible today.

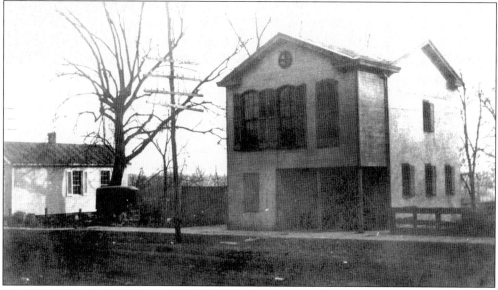

Until the jail at the Administration Building was completed in 1981, lawbreakers were held in a succession of small jails built on a lot directly across from the courthouse. Shown here about 1900, this building was the third county jail to occupy the site. Completed the same year as the Clerk's Building (1854), this jail cost $2,000. By 1883, an article in the *Boone County Recorder* cried that the old jail was "not fit to keep hogs in!" In 1885, the building was remodeled at a cost of $7,000. The project included the addition of a six-foot-wide, wood-frame facade and installation of a pair of more secure cells on the first floor. The building was used until 1928, when it was replaced by a small bungalow-style jail building.

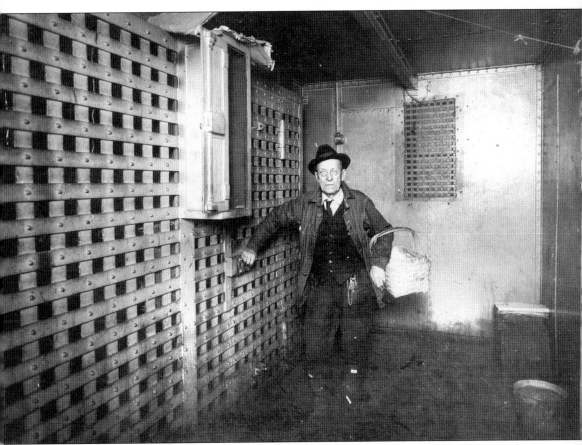

In this *c.* 1925 photograph, Boone County jailer Charles A. Fowler pauses during his rounds in the old Boone County jail. Born in Burlington in 1857, Fowler was educated in Burlington schools and moved to Athens, Ohio, in 1885, where he painted houses in the summer and taught dance in the winter. After returning to Burlington, he and his wife operated the Boone House Hotel for two years. Upon winning the office of jailer, he left the following inscription on the wall of the attic in the old courthouse: "C.A. Fowler sworn in as Jailer No 15, 1917." Fowler became jailer nearly 70 years before the Kentucky jail standards were adopted in 1984. In some counties, the jailer and his family had living quarters at the jail, and the entire family assisted the jailer. During his dozen years as Boone County jailer, Charles Fowler took charge of 356 prisoners.

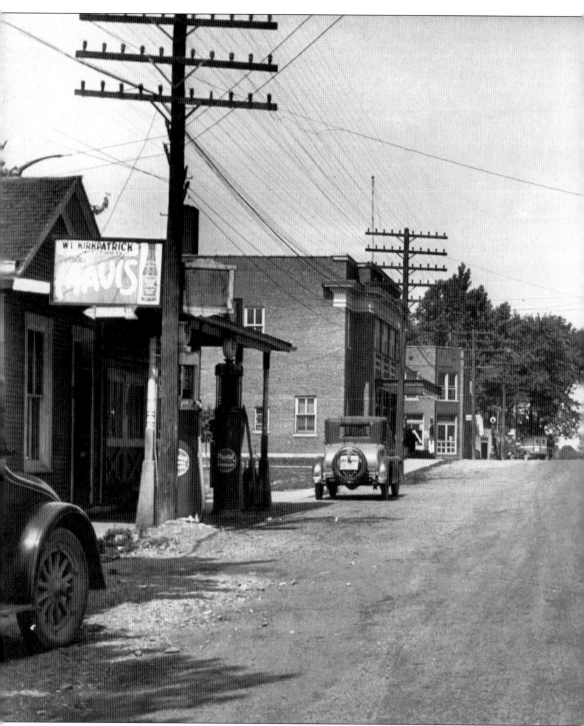

While some things along Washington Street (Burlington Pike) in Burlington have changed since 1930, the streetscape is unmistakable. Kirkpatrick's store on the left has been the home of the Little Place Restaurant for over 30 years. Just beyond on the left, the Boone County Deposit Bank building now houses the Boone County Planning Commission. Smith's corner

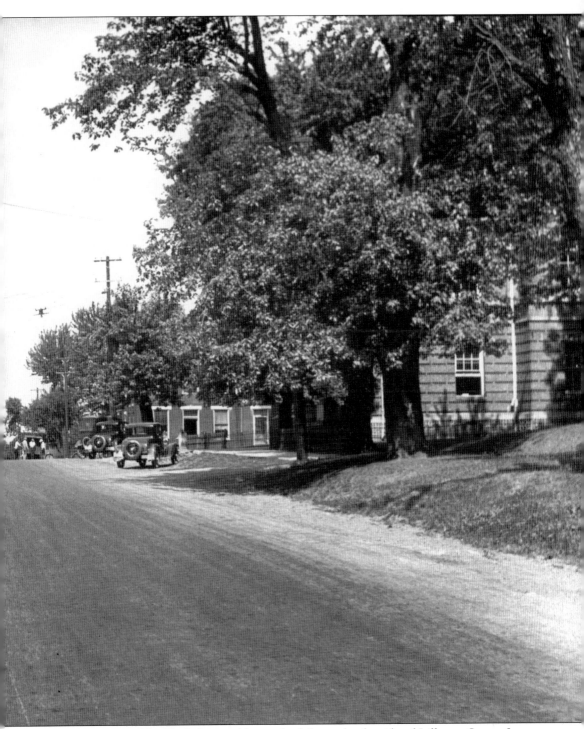

store (then owned by Blythe) is visible on the left on the far side of Jefferson Street. It was demolished in 2002. On the right, the old Burlington Hardware Store has recently been restored as the County Seat Restaurant.

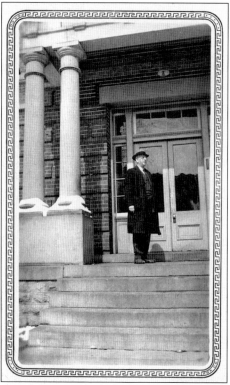

Shown here on the courthouse stairs in 1932, Nathaniel Edson Riddell was born and raised in Burlington. After studying law at what is now the University of Cincinnati, Riddell returned home, where he became county attorney in 1906 and county judge in 1920. Under his leadership, toll gates were removed from county roads, a new jail was built, and the courthouse received a new heating system.

This 1966 photograph depicts Billie Joe Morris in front of the Renaker House on Union Square. Constructed about 1830 for Elijah Kirtley, the building housed the Boone House Hotel from 1830 to 1870. It later became the residence of Fountain Riddell, attorney, state legislator, and founder of the Boone County Deposit Bank. It then became the home of A.B. Renaker, Riddell's son-in-law and cashier of the Deposit Bank. Supposedly haunted, the Renaker House has been occupied by various state and county agencies over the past few decades. It was restored by Boone County in 1992 and currently houses the county's Department of Human Services.

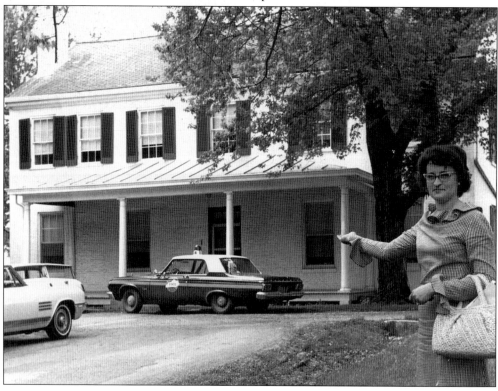

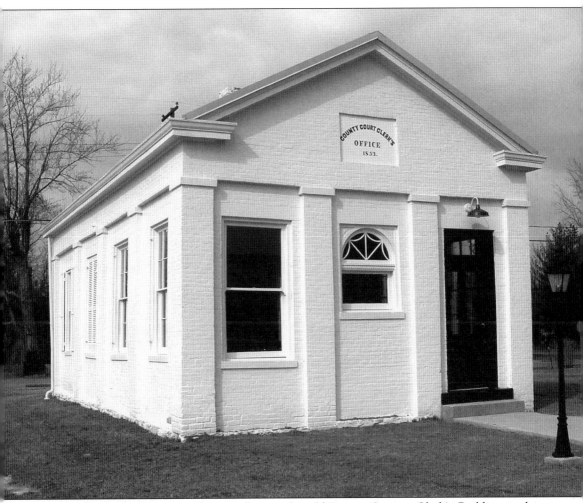

Originally located opposite the courthouse, the old Boone County Clerk's Building is the county's sole surviving government building of the antebellum era. Begun in 1853 and completed in 1854, it is a well-proportioned, temple–form, Greek Revival, brick structure, distinguished by brick pilasters that mark the bays on all sides. The facade originally had a centered door, but the building was remodeled and a metal vault installed after it was sold and converted into a bank in 1889. From 1889 to 1924, the building housed the Boone County Deposit Bank. When a new bank building was constructed in 1924, the old Clerk's Building was moved across Jefferson Street and converted to a post office, a capacity in which it served until 1959. In 2001–2002, the old Clerk's Building was saved from demolition, moved to its current site, and completely restored.

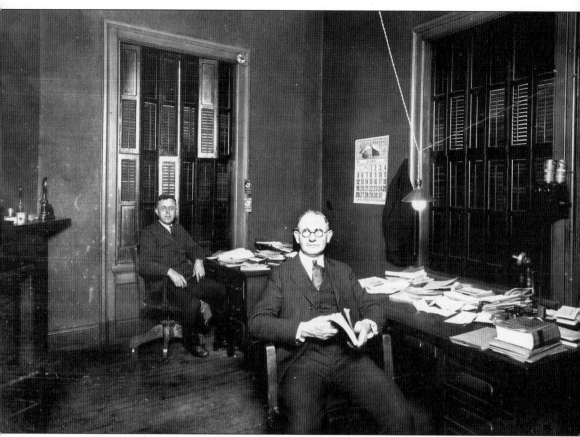

This 1926 photograph shows County Clerk Asa McMullen (foreground) and his assistant, Mark Cook, seated in their shared office in the 1889 Boone County Courthouse. Mr. McMullen was widely regarded in Burlington. He was a charter member of the Gunpowder Baptist Church and later a deacon of Burlington Baptist Church. He served as county clerk from 1925 to 1933 and also built a number of stylish bungalows that were popular in the 1910s and 1920s. Mr. Cook and his family lived in a house that still stands on Camp Ernst Road at the intersection of Rogers Lane. He worked for the Boone County Agricultural Conservation offices for a number of years.

Born in a farm house near Bullittburg Baptist Church, Carroll Lee Cropper (1897–1976) graduated from Burlington High School in 1916. After a stint in the army in World War I, he went to work as a bank cashier and eventually became vice president of the Peoples Deposit Bank. In 1934, he was elected as a state representative, serving Boone and Grant Counties, and he served as acting Boone County judge for 12 years when Judge N.E. Riddell was not able to attend meetings. When Riddell died in September 1942, Cropper was appointed judge for the unexpired term. Cropper won the 1943 election and served 20 years as county judge. During his tenure, Cropper witnessed the development of the airport, the opening of Big Bone Lick State Park, and construction of Interstate 75. C.L. Cropper was one of only four long-serving judges between 1901 and 1982.

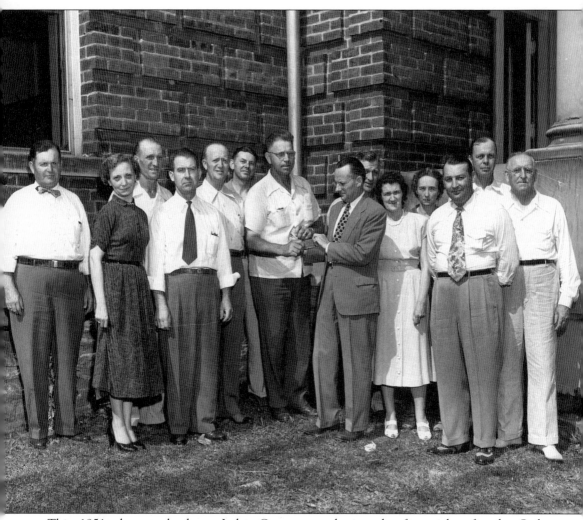

This 1951 photograph shows Judge Cropper purchasing the first ticket for the Soil Conservation Service Air Tour of Boone County. The 30-minute flights originated at the Greater Cincinnati Airport and covered 60 miles. The purpose of the not-for-profit tour was to "acquaint the public with the importance of soil building." Shown in the photograph are, from left to right, (front row) William R. Ellis (air tour promotion committee), Mrs. Alberta Green (deputy county clerk), A.D. "Eck" Yelton (circuit court clerk), Charles Liston Hempfling (air tour chairman), Judge Cropper, William P. McEvoy (county attorney), and A.B. Renaker (president, Peoples Deposit Bank); (back row) Byron Kinman (deputy county sheriff), Wendell H. Easton (county sheriff), John Crigler (farm bureau), C. Dewey Benson (county clerk), Ora Yelton, Mrs. Catherine "Mabel" Easton, and R.M. "Coke" Hall (state representative from Walton).

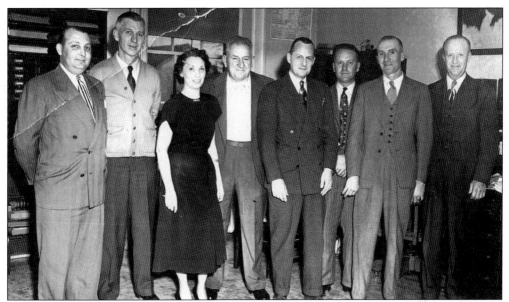

In 1950, Boone County employees posed in the old courthouse with Judge Cropper. Pictured are, from left to right, Bill McEvoy (county attorney), Dewey Benson (county clerk), Mrs. Alberta Green (county clerk secretary), Cecil "Pie" Presser (jailer), Carroll L. Cropper (county judge), Wilton Stephens (tax commissioner), Byron Kinman (deputy sheriff), and Wendall Easton (county sheriff). The picture was taken by Russell Manual, a commercial photographer from Ludlow, Kentucky.

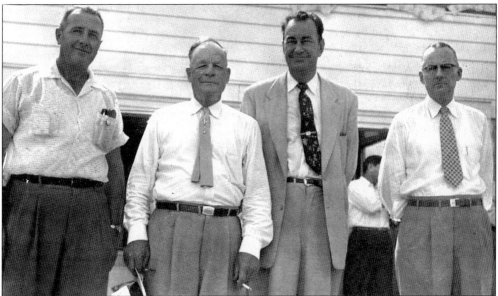

Judge Cropper is seen here at right in this c. 1955 photograph. Gov. Lawrence Wetherby of Kentucky stands next to Cropper. The two men at left are unidentified. During Wetherby's tenure as governor (1950–1955), he encouraged public education, conservation measures, and mental-health reforms. Wetherby supported the U.S. Supreme Court's 1954 decision on school desegregation. In 1956, Wetherby was defeated in the senate race by Republican John Sherman Cooper.

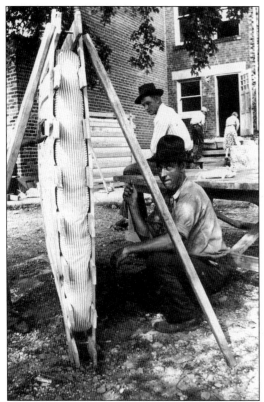

In 1941, the Cooperative Extension service oversaw Boone County's participation in the Mattress Project. This nation-wide project used the surplus cotton of the South to help American families. The program's regulations said that any family that had not made $500 the year before was eligible to participate in the "make your own mattress project." In Boone County, school buildings served as centers and much of the work was done outside on pretty days. The raw cotton was supplied by the United States Department of Agriculture and fluffed by hand on site. These pictures from the Burlington School show the last two stages in the process of making a mattress: tufting (top) and sewing on the roll (bottom). Thanks to the labor of 150 farm families, Boone County's Mattress Project generated a total of 233 mattresses and 226 comforters at 5 community centers.

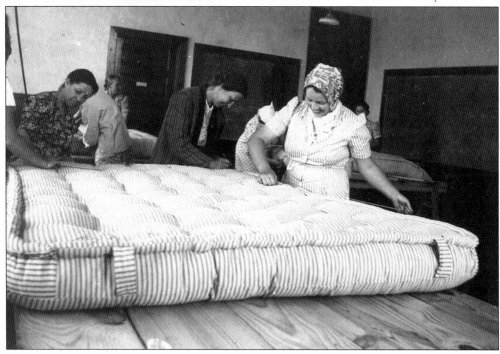

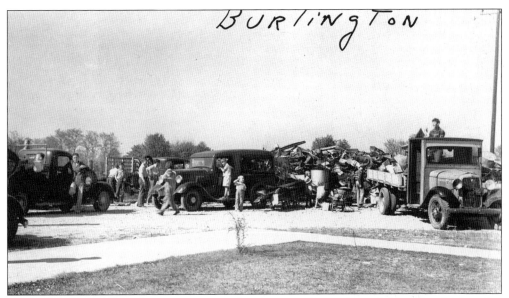

In October 1942, Boone County participated in a state-wide scrap-metal drive aimed at keeping the nation's steel mills running at capacity. Kentucky's quota was 100 pounds per person. The County Salvage Committee offered a $25 Series E war bond for the Boy Scout, 4-H Club, Future Farmer, or other high school boy collecting the most pounds over 40,000. The scrap pile pictured at the Burlington School was one of 10 located at schools around the county.

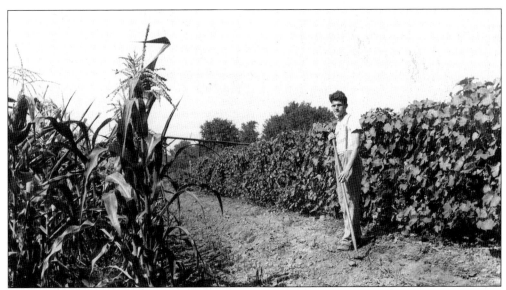

Raymond Witham poses in his "Live at Home" garden in this photo taken on July 29, 1941. Sponsored by Homemakers Clubs and 4-H, the "Live at Home" program stressed production of large amounts of vegetables to feed families. Raymond's garden included 17 varieties of vegetables and 28 varieties of fruits. That year, Raymond's mother canned a total of 492 quarts of fruits and vegetables.

These pictures show participants in the Boone County Wool Pool delivering wool to Burlington on June 19, 1941. Under the guidance of association president Hubert White, wool was received at Burlington, Walton, and Petersburg with the goal of getting the best price for Boone County's sheep growers. The year 1941 was the second-best year for the association, which lasted into the mid-1950s. The Wool Pool received 64,822 pounds of wool from 353 sheep-raisers around the county. The collected wool was sold to W. Sable Sons of Louisville for $30,429.18.

During World War II, the United States government legalized hemp cultivation and encouraged American farmers to grow it for the war effort. The fibers were used to make rope, textiles, and other materials in short supply during the war. Boone County Extension agent Holly Forkner initiated a complete educational program, from the securing of seed to planting, thinning, harvesting, and marketing. Eleven Boone County farmers grew hemp in 1941; only one of them had seen the crop before. The top picture is from the May 8, 1942, hempseed planting demonstration at Hugh Stephens's farm. At right, hemp is seen growing in late June on the Raymond Ashcraft farm in East Bend Bottoms. The continued rainy weather after cutting time and high winds caused damage to one-half to three-fourths of the total crop. In the end, growers received slightly less than 10 bushels per acre. The program did not continue in 1943.

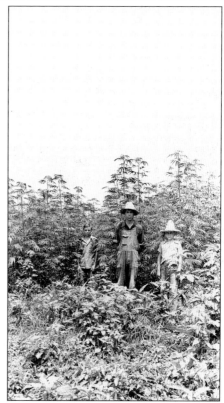

The Boone County Infirmary, built in the 1870s, was located on Idlewild Road (Highway 338), just past the Boone County Fairgrounds. At the time this picture was taken in 1918, the building had no indoor plumbing and was heated by coal. A furnace and indoor plumbing would not be added until the 1930s. As a home for the indigent of the county, the facility was also known as the "poor house." In 1969, the last residents of the infirmary were moved to the newly completed Woodspoint Nursing Home. In 1970, the building took on a new life as the Maplewood Children's Home.

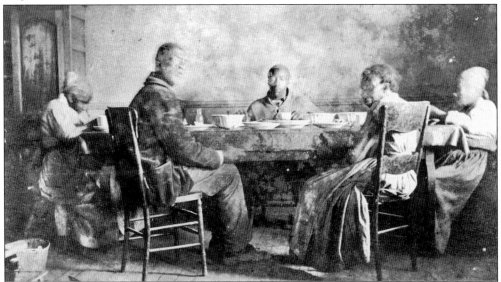

Taken in the early years of the 20th century, this picture shows several of the residents of the Boone County Infirmary as they dine together. The picture was taken by Frank Rouse, who was hired by the county to run the infirmary. In the diary that he kept all of his adult life, Rouse recorded that for Christmas in 1911, each resident received "a plate of candy, nuts, an orange, banana, dates, peanuts, and a handkerchief. Also, some little gifts such as a knife, coinholder, etc."

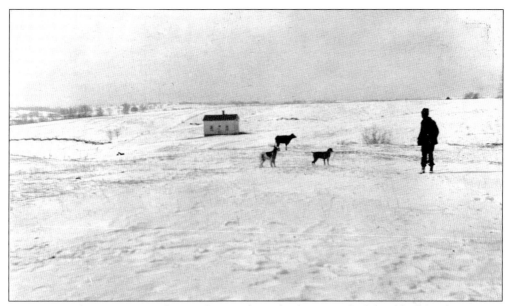

On a winter day in 1918, Walter Seales stands in the foreground of this bleak landscape near the Boone County Infirmary. The small building in the background is the "pest house." County residents diagnosed with contagious diseases could be housed here so as not to infect the general population. Scarlet fever, diphtheria, and tuberculosis were three maladies that could require patients to spend time at the "pest house."

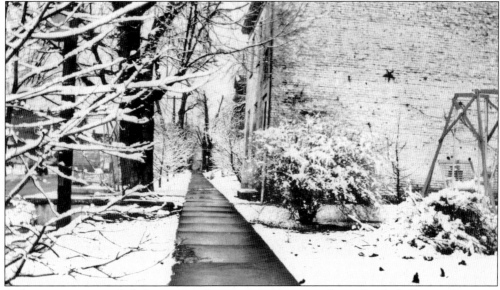

A late-winter snow lightly covers this streetscape view along South Jefferson Street in Burlington. This early 19th-century brick home was located across the street from the site of the new Boone County Justice Center. Several months would pass before the residents of this house would be able to use the snow covered swing in the foreground.

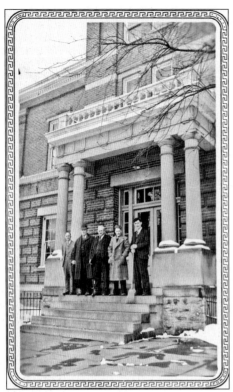

The note on the back of this postcard states "Men of the Courthouse, 1932." This card is a counterpart to a similar postcard inscribed "Ladies of the Courthouse." Although none of these men are identified, it is presumed that they held various county offices under Judge N.E. Riddell. The original wood entrance to the courthouse is visible in this picture. The courthouse's wood entrance was rebuilt in 2003 and closely resembles the original.

Pictured from left to right in this c. 1960 photograph are Floyd Kells, Kenton County judge-executive Jim Dressman, and Larry Helmer. Floyd Kells dedicated much of his life to soil and farm conservation in Boone County. Mr. Kells was district conservationist in Boone, Kenton, and Campbell Counties from 1950 to 1977 and served on the board of directors thereafter. (Photograph by Bob Sharpe.)

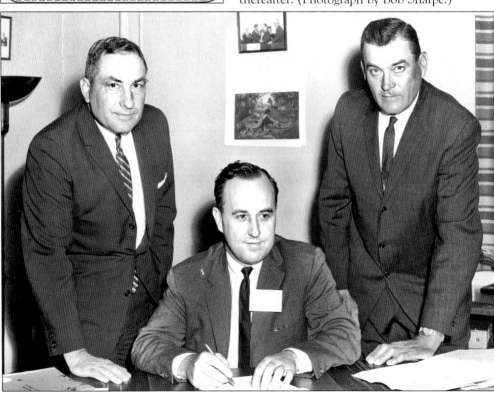

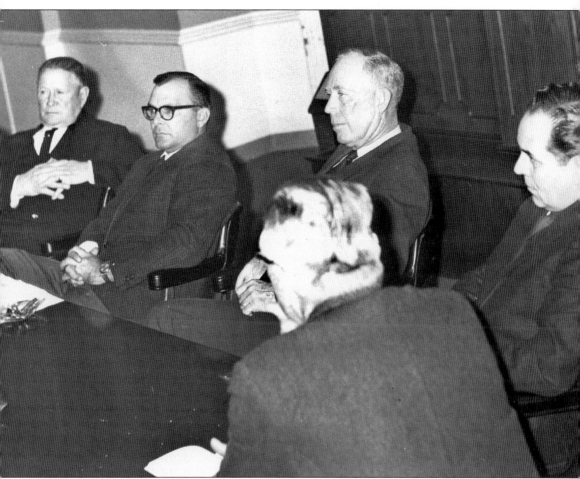

Judge Bruce Ferguson is shown here with the three members of Boone County Fiscal Court on January 17, 1968. Pictured are, from left to right, Charlie Carpenter, Judge Ferguson, David Houston, and Charles Patrick. This was the first meeting of the fiscal court following the voters' decision to switch from the justice of the peace/magistrate system to the commissioner system of elected representation. At present, only 16 of 120 Kentucky counties have commissioners, although nearly half of all Kentuckians live in those counties. Boone County still retains three justices of the peace or magistrates, who may preside over marriages. (Photograph by *Kentucky Post* photographer Ken Beagle, courtesy Kenton County Public Library.)

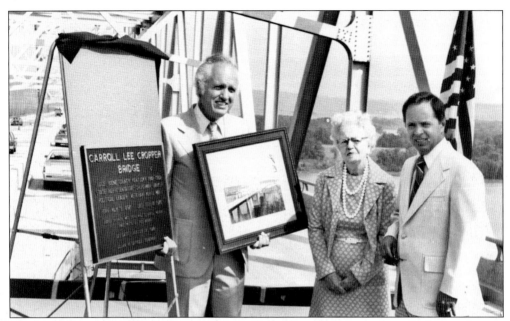

The bridge between northwest Boone County, Kentucky, and Lawrenceburg, Indiana, is known as the Carroll Lee Cropper Bridge, part of Interstate 275. The bridge was named in honor of long-time Boone County judge-executive Carroll Cropper. During his 20 years in office, Cropper worked effortlessly to see the construction of this vital link across the Ohio River. The bridge bearing his name was dedicated on December 5, 1977, not quite two years after Cropper's death in February 1976. Pictured here at the dedication are, from left to right, Gov. Julian Carroll, Mrs. Carroll Cropper, and John Cropper.

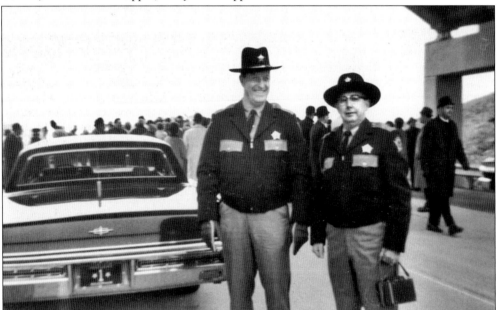

Pictured are two of the men who served Boone County as sheriff. Melvin Collins (left) served two terms as sheriff. He was succeeded in office by Ruben Kirtley (right). It was during this time that local country-music star Kenny Price recorded his hit song "Sheriff of Boone County."

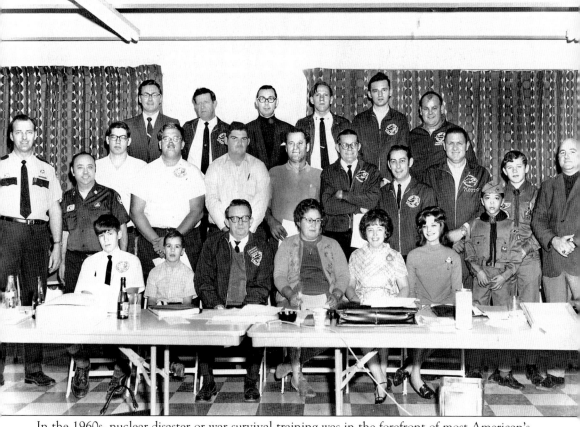

In the 1960s, nuclear disaster or war survival training was in the forefront of most American's minds, and local civil defense groups were popular. In 1965, Boone County civil defense director Robert Coffey, shown here at far right, planned an overnight disaster readiness demonstration in the basement of Boone County High. The 34 participants were told that radiation levels outside were deadly. They listened to taped messages from Governor Nunn and a "concealed" White House detailing where they had been hit and the response to the enemy before going to sleep for the night. Jim Klosterman was the only person awake at 5 a.m. when a boiler malfunction sent steam gushing through the school. Everyone was evacuated from the building. The mishap is remembered well by current Boone/Gallatin circuit judge Tony Frohlich, the teenage Boy Scout standing next to Mr. Coffey. Tony's father Ken Frohlich is pictured in uniform at far left; he served as civil defense communications officer.

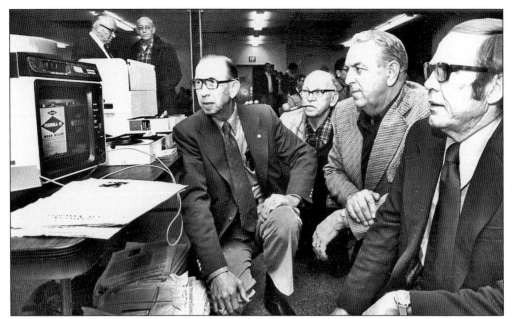

As a county agriculture agent, Joe Claxon Jr. worked one-on-one with farmers to help introduce new products that could help improve crop quality or yield. In this late-1970s photograph, Mr. Claxon uses a caramate projector to present the potential uses of Dow Formula 40 Weed Killer to a group of Boone County farmers. Pictured are, from left to right, Atlas Lynn (a game warden), Bill Rowland, Joe Claxon Jr., James Franklin Brown, Vaughn Hempfling, and Bob Ellis.

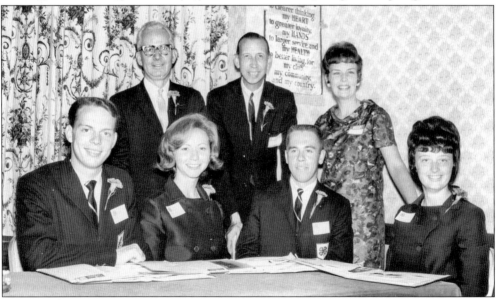

This early 1960s photograph was taken at a 4-H "Report to the Nation" meeting. The student representatives from around the country were responsible for publicizing upcoming events of the local club, compiling a club history, and keeping a scrapbook of the club activities. Pictured are, from left to right, (front row) Joe M. Day of Kentucky, Martha Poland of West Virginia, Jeff Muchow of South Dakota, and Sherry Smith of Arizona; (back row) national 4-H representative Ken Anderson, Joe Claxon Jr., and Nancy White.

Two

COMMUNITY
Churches, Schools, Sports, and the County Fair

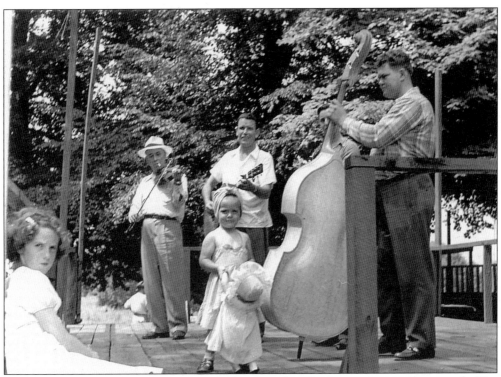

This c. 1953 photograph was taken at the bandstand at the Boone County Fairgrounds. The bandstand was located in a grove of trees that stood where the Lents stage is now located. From left to right, Frank Miller, Jimmy "Turkey" Feeley, Freddy Fields, and Bernard Delph provide the music for Liz Griffith and Turkey's granddaughter Judy, who is dancing with the doll. (Photograph by Frank S. Milburn.)

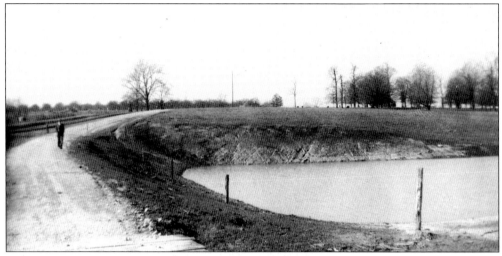

A true multi-day county fair in Boone County was held in Florence from 1855 to 1881 (with a hiatus during the Civil War) and again from 1896 to 1933, when the Great Depression forced its closure. The old one-day fair continued at the Harvest Home Fairgrounds in Limaburg and gained in popularity after the 4-H and Utopia Clubs moved there in 1936. When the Harvest Home Fairgrounds were sold, the one-day fair moved to the Burlington School grounds. In 1942, the present fairgrounds on Idlewild Road was purchased. This November 1942 photograph shows the dam at the fairgrounds, which was completed in July of that year at a cost of $1,050. The Boone County 4-H and Utopia Fair at Burlington has since grown to a week-long event held the first week of August. The fairgrounds also host important community events ranging from the annual seniors picnic to the Burlington Antiques Show that attracts thousands of people on summer Sundays.

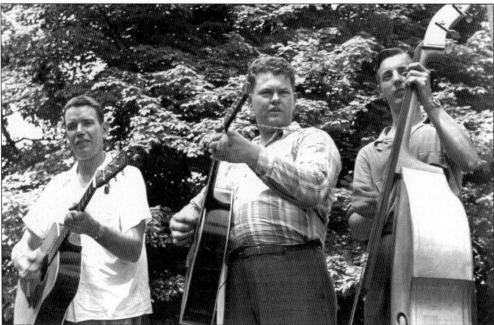

From left to right, Jimmy "Turkey" Feeley, Bernard Delph, and Freddy Fields perform at the Boone County Fairgrounds in this c. 1953 photograph. (Photograph by Frank S. Milburn.)

34

John E. Crigler (left) and Hubert "Hube" White show off Ray Smith's prize-winning horse at a 1950s horse show at the Boone County Fairgrounds. Mr. Crigler was the county's farm bureau agent. Mr. White was the president of the Boone County Wool Pool and also owned the White Farm on East Bend Road (Photograph by Frank S. Milburn.)

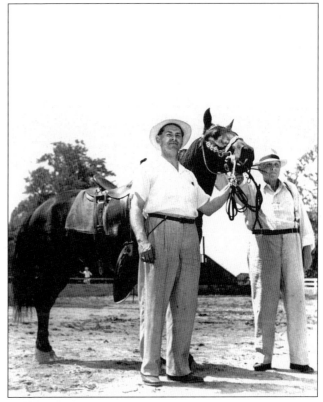

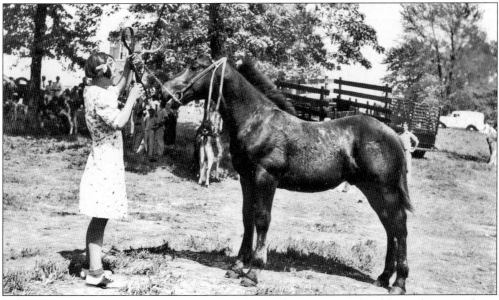

Thelma Anderson, a 4-H Club member, shows her five-month old Percheron colt in competition in 1941. The colt was judged champion over all other entries in the colt class. Many young people in the county were members of the 4-H Club and would show their animals in competition at the annual 4-H and Utopia Fair. This picture was taken on the grounds of the old Burlington School. A year later, the fair moved to its present location on Idlewild Road

Betty and David Flack enjoy a picnic at the Boone County Fairgrounds in 1949. The 4-H and Utopia Club Council, cooperating with the Fair Grounds Purchasing Committee, spent $5,400 to purchase and equip the fairgrounds. The first fair held at this site in Burlington was on August 12, 1942, and it attracted 4,000 people.

Mary and Glenn Dickerson enjoy the festivities at the Williams family reunion, held at the Boone County Fairgrounds in the summer of 1949. At that time, the fairgrounds was often used for social events, both public and private.

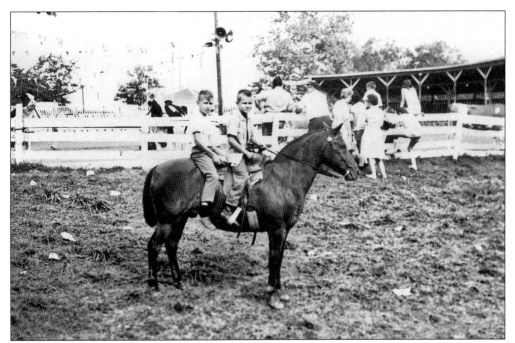

In this *c.* 1970 photo, two boys and their pony are shown near the show ring of the Boone County 4-H and Utopia Fair. The first-known colt show in Kentucky was held during the 1941 Boone County Fair. A total of $24 in prizes was given at the pony show that year.

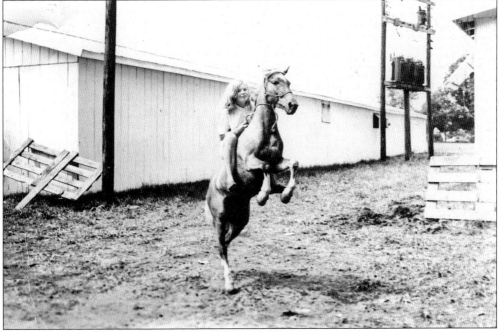

Since its organization in 1925, the Boone County 4-H Club has played an important role in the annual Boone County Fair. This young lady on her pony, shown here at the fairgrounds about 1970, is one of the thousands of 4-H Club members who over the years have proudly exhibited their animals, crops, and projects at the fair.

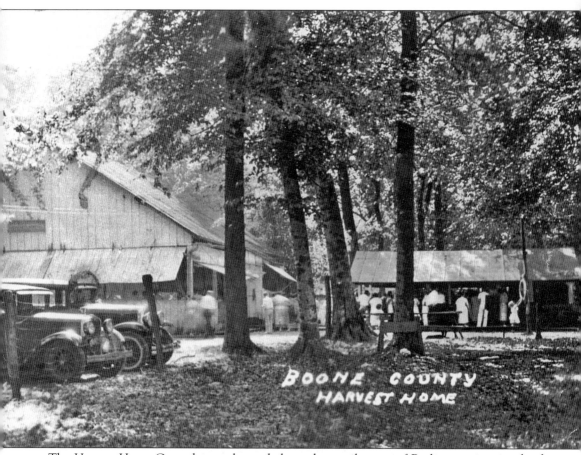

BOONE COUNTY
HARVEST HOME

The Harvest Home Grounds were located about three miles east of Burlington, just north of Limaburg on Limaburg Road. The first Harvest Home held on the site was in 1896. At its peak, the annual event, which was held in September, ran for two days. The number of spectators, premiums, and competitors was equal to many local county fairs. When the Harvest Home celebrated its golden anniversary in 1936, invited guests included Gov. A.B. "Happy" Chandler and U.S. Rep. Brent Spence. During the 1930s, there were actually two fairs held on the site, as the Boone County 4-H and Utopia Fair was also held at the Harvest Home Grounds before moving into Burlington.

Burlington's churches have always been an important aspect of their parishioners lives. Burlington Baptist formed in 1842 and is today very active in the community. Rev. Roy A. Johnson (1897–1977) served as pastor of Burlington Baptist from 1941 to 1952. His "Christmas call" is one visible example of the close connection between pastor, the congregation, and the community.

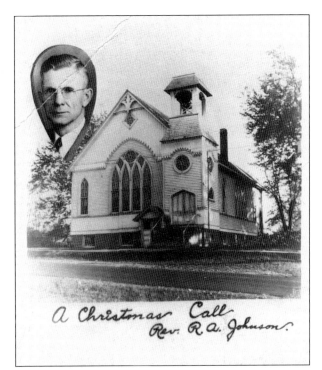

A Christmas Call
Rev. R. A. Johnson.

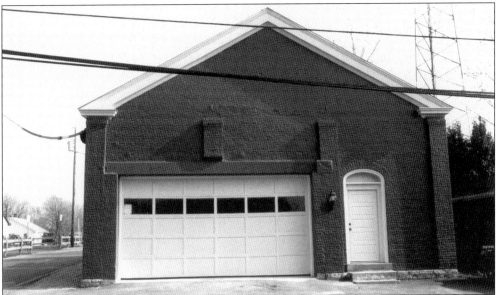

Originally constructed with two front entrances, the c. 1835 Burlington Presbyterian Church has been a church, library, movie house, fire station, and garage. It is a fine example of temple-form Greek Revival architecture. The trustees of the Burlington Church of Presbyterians bought the lot in 1834 and sold it to the Boone Library Association in 1908. The Presbyterian church was never very vibrant in Burlington, which is probably why the building was sold nearly a century ago. One of the two original front doors was destroyed when the building was converted to a fire station around 1963. The building was rehabilitated in 2002 and now houses the Boone County Maintenance Department.

Edith Mae Webb stands in front of the entrance to the First Baptist Church of Burlington in this c. 1950 picture. Tucked away in a corner of Burlington on Nicholas Street, the church was established in 1881, chiefly by Burlington's African-American Strader, Early, and Webb families. At that time, there was one other African-American Baptist church in Burlington, along with a Universalist church. Today, only the First Baptist remains, but its tiny congregation still revels in the church's tenets of spiritual growth, education, and community involvement.

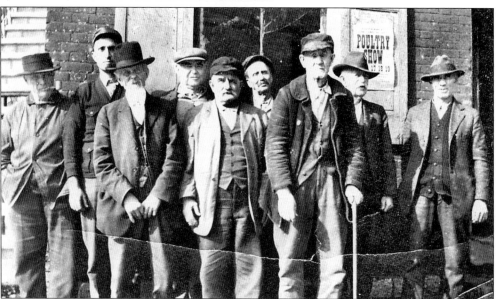

The Central House Hotel (now the County Seat Restaurant) was a popular place for posed pictures. Only four of the nine individuals in this c. 1915 line-up of Burlington men have been identified. Lloyd Weaver is the tall man second from the left, and Dr. M.A. Yelton's father is the older man with the white beard. Ed Rice stands second from the right, and Mr. Hensley is holding the cane. The flyer advertises the fourth annual Boone County Poultry Show, although the date is not visible.

Boone County's first private school was the Morgan Academy, located immediately south of the Old Burlington Cemetery. Begun as the Boone Academy in 1814, many of Burlington's leading citizens were educated at the academy during the 19th century. During the Civil War, a rumor circulated that one of the academy's teachers was actually John Wilkes Boothe, which of course, was false. The academy closed in the 1890s, and the lot is now vacant.

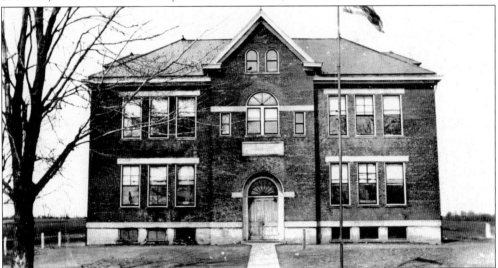

By 1907, lack of faith in Burlington's small public school on Washington Street led to an outcry for something better. Responding to local interest, Rev. Edgar C. Riley opened a graded school in the public school building in September 1909. Tuition was set at $40 per session for high school and $25 for lower grades. A large brick school building was then constructed on a lot in the northeast corner of town. The new school was occupied in February 1911, with the "common" school in a room on the first floor and the high school in the two second-floor rooms.

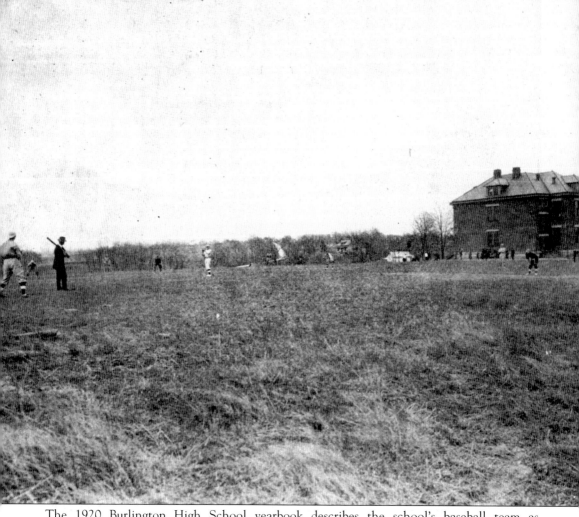

The 1920 Burlington High School yearbook describes the school's baseball team as "exceedingly strong." Seen here playing on the field behind the old Burlington High School, the baseball team that year had 11 players. Included in the team's schedule were two games with Lawrenceburg (Indiana) High School. The first game, at Lawrenceburg, was called on account of rain at the end of the fifth inning. At their second meeting in Burlington, Lawrenceburg was defeated by a score of 8 to 7. It was then decided to play the four innings left from the first game, and Burlington won its second victory of the day, 7 to 6.

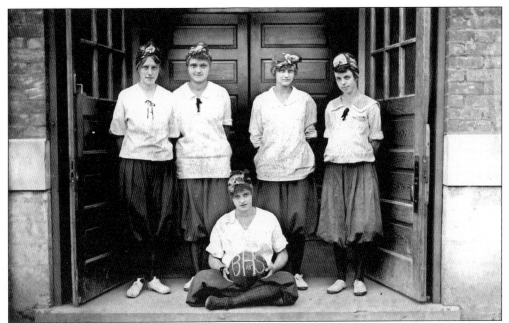

The 1915 Burlington High School girls basketball team poses in the front entrance of the old Burlington School. Standing from left to right are unidentified, Alberta Stephens, unidentified, and Katherine Cropper. Lallie Rice is seated and holding the basketball.

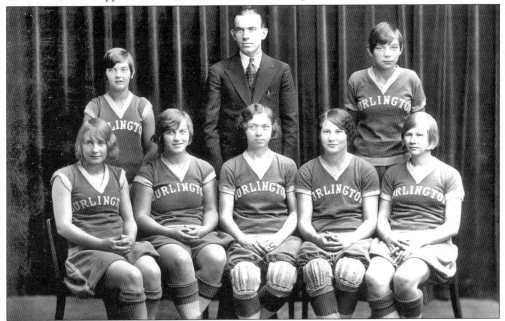

The 1929–1930 Burlington girls basketball team is shown here. Pictured from left to right are the following: (seated) Mary Phillips, Virginia Yelton, Lucille (Rice) Smith, Mary B. Rouse, and Martha Blythe; (standing) Ethel Ryle, Coach ?, and Lucille Ryle. If nothing else, the photograph shows that the uniforms worn by the girls at that time were comparable to those of the boys basketball team and not nearly as conservative as those worn by the 1915 girls basketball team.

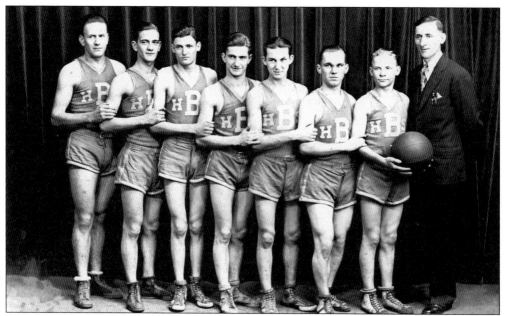

The 1930–1931 Burlington High boys basketball team poses with their coach Mr. Lamb. Pictured are, from left to right, ? Smith, Stanley Ryle, Frank Maurer, Phil Greenup, Jim Ogden, Wallace Ryle?, and Pete Stephens.

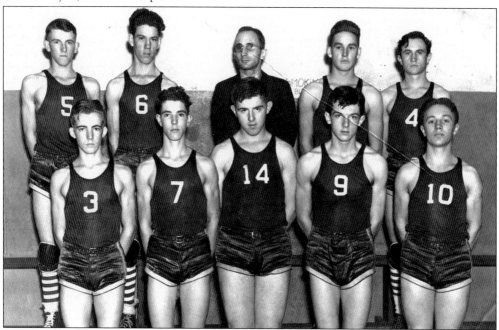

Taken in 1939, this was the last boys basketball team at the old Burlington High School. Pictured are, from left to right, (front row) Dudley Rouse, Edward Rogers Jr., Marvin "Top" Porter, Charles Benson, and Wilfred Huey; (back row) Ivan Gulley, Joe King, Coach Edwin Walton, Leroy Bethel, and Clayton Clore. Edward Rogers served in the army during World War II. He was one of the more than 12,000 American servicemen killed in the Battle of Okinawa in April 1945.

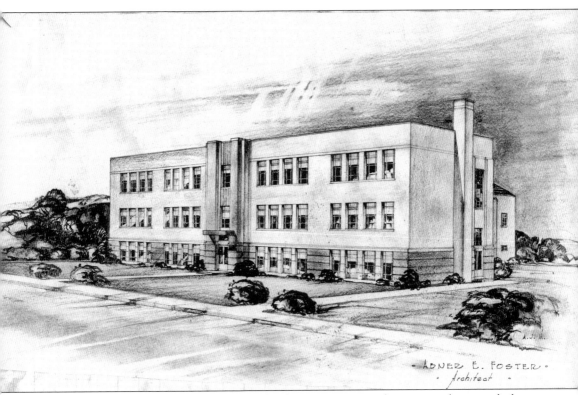

- ABNER E. FOSTER ·
· Architect ·

By the late 1930s, the 1911 Burlington School was in surprisingly poor condition and plans were made to construct a new facility. Boone County Fiscal Court retained architect Abner E. Foster to design a new school and issued bonds to cover 55 percent of the $81,550 total cost. A grant from the Public Works Administration (PWA) program covered the remaining 45 percent. Foster's architectural rendering reveals his plan for a Burlington School designed in the then-popular Art Moderne style. Walton's prolific builder George Nicholson won the bid as general contractor for the project, and Burlington's Poston Brothers did all the electric work. The new school was built in front of the old school in only eight months. It opened on September 25, 1939, with an enrollment of 228 pupils.

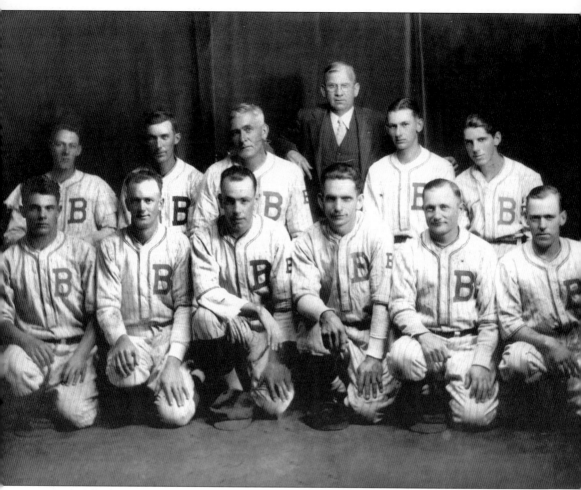

The Burlington baseball team featured in this 1920s photo includes Roscoe Akin, in the front row on the far left. Courtney Kelly is seated second from the right in the front row. The team was coached by Dudley R. Blythe, who wears a suit in this photograph. The rest of team has not been identified. As far back as the 1870s, Boone County had organized semi-professional baseball teams, and Burlington fielded teams in organized leagues up until World War II. The Boone County league of the 1920s and 1930s was particularly popular and gained regular newspaper coverage and fan support. Home games were played on a field located along present Park Street across from the Old Burlington Cemetery. Long-time Burlington player Herbert Kirkpatrick is said to have laid out the field "with a ruler, fine tooth comb, and level," making it one of the best in the area.

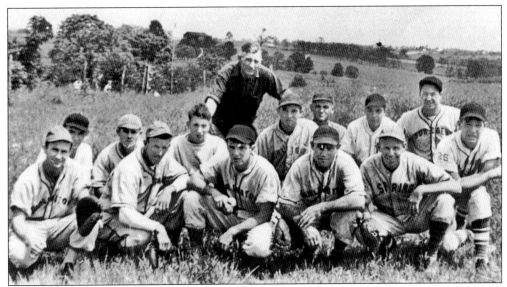

This 1947 team photo of the Burlington baseball team was taken during a trip down to Verona. At the time, the team was coached by Dewey Benson, who stands behind the team. Pictured, from left to right, are (front row) Jack Clore, Ivan Gulley, Charlie Benson, Albert Sebree, Don Kirkpatrick, and Dewey "Sox" Benson; (back row) James Gayle Smith, Roscoe Akin, ? Poole, J.D. Daley, Jake Long, Dave Clore, and Alvin Clore. Sox was Burlington's best player and even tried out for the Cincinnati Reds at Crosley Field.

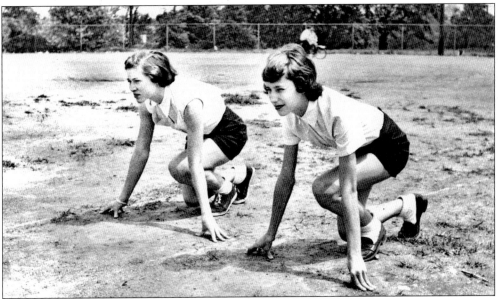

In one of the early county track meets, Burlington High School students Sylvia Ransom (right) and Mary Lou Dringenburg compete in the 50-yard dash. This picture was taken in the spring of 1954. The following year, these Burlington High juniors joined those from Florence, New Haven, and Hebron high schools to become part of the first graduating class of the new Boone County High School. While on the Burlington track team, Mary Lou set a new record for the broad jump. Her daughter, Cindy Holbrook, would later also set a broad-jump record while a student at Conner High School.

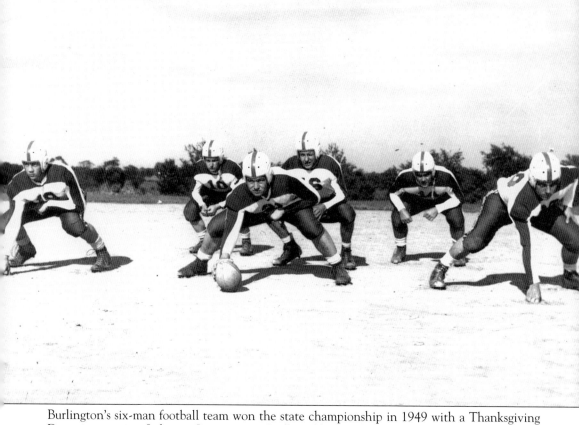

Burlington's six-man football team won the state championship in 1949 with a Thanksgiving Day victory over Lebanon-Junction at Stoll Field in Lexington. Coach Edwin Walton's Burlington Eagles went undefeated that season, dominating the other teams in their Northern Kentucky league by an average score of 61 to 12. Their most lopsided win was a 92–6 shellacking of New Haven. The 6-man version of football was developed in 1934 for use in small schools where enrollment was too low to fill the roster of a full 11-man squad. From left to right in this team photo are the following: Gayle Rouse (right end), Robert Walton (right halfback), Wayne Kelly (center), Sonny Ockerman (quarterback), Jimmy Ryle (left halfback), and Bill McBee (left end).

Three
BUSINESS
Restaurants, Hotels, Shops, and Industry

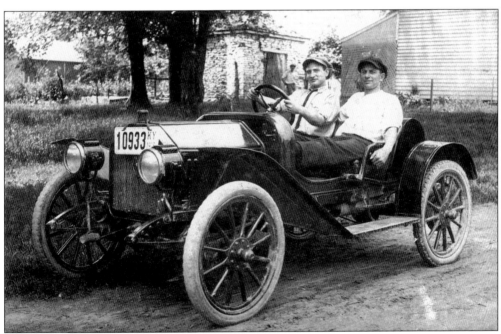

In this 1915 image, Stanley "Boss" Eddins and brother Leonard "Jack" Eddins proudly display a custom-built car that roughly resembles a 1913 Ford Model T Roadster but is probably a composite of several makes and models. The photo was taken on Washington Street, just east of Garrard Street in front of what is now the telephone company substation. The stone building in the background is a smokehouse, and the structure on the left was an African-American Baptist Church that fronted on Garrard Street.

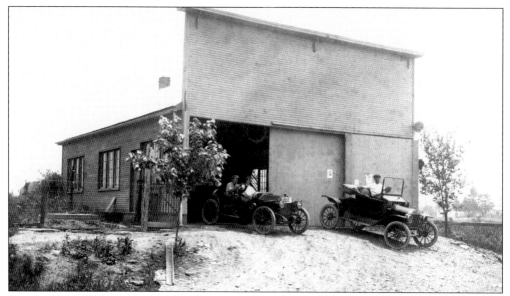

Boss and Jack Eddins operated the first auto repair shop in Burlington. This 1915 photograph shows the Eddins Brothers Garage, which stood on the east side of East Bend Road just before it drops down to the bridge over Allens Fork. An advertisement in the Burlington School's 1915 *Purple & Gold* Yearbook noted that "Ford Repairs and Supplies [were] a Specialty." An ad in the 1914 *Boone County Recorder* stated that they had an "Auto for Hire at All Hours." A third Eddins brother, Jess, later moved the shop to the southwest corner of Union Square.

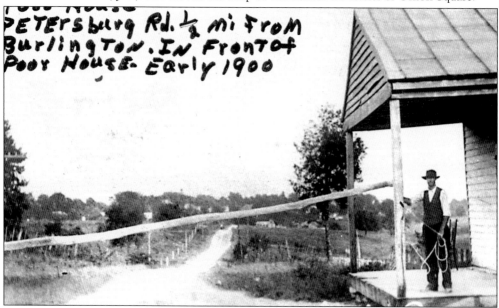

This *c.* 1900 photograph shows the toll house that once stood on the Petersburg and Burlington Pike in front of the county infirmary or "poor house." The Petersburg and Burlington Turnpike was incorporated in 1849 and completed in late 1850, providing a good road between the county seat and Boone County's largest town. By the 1910s, toll roads had become very unpopular with residents, who demanded their abolishment. In 1918, Boone County bought the Petersburg and Burlington Turnpike for $10,000.

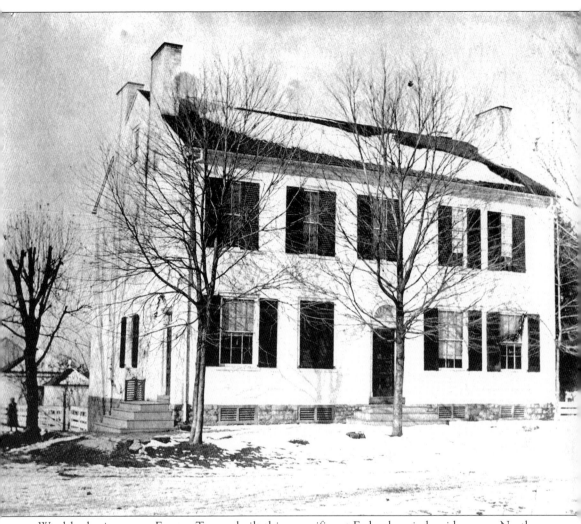

Wealthy businessman Erastus Tousey built this magnificent Federal-period residence on North Jefferson Street sometime after he acquired the lot in 1817. Erastus lived in the house with his wife, Catherine, and family until his death in 1863. After Catherine's death in 1895, the house changed hands several times before the Gulley and Pettit families bought it in 1917. Gulley and Pettit operated a general store in two first-floor rooms before moving to a location on South Jefferson Street. The facade of the Tousey House is laid in Flemish bond, and the bays are topped by finely constructed flat and semicircular arches of gauged brick. Paired chimneys rise from the gable ends. Former Boone County judge-executive Bruce Ferguson rehabilitated the property in the late 1980s; in 2001, it was extensively rehabilitated and converted to the Tousey House Restaurant.

BURLINGTON ADVERTISER.

Y W. H. NELSON. BURLINGTON, BOONE COUNTY, KY., SATURDAY, OCTOBER 13, 1849. VOL.

SELECT POETRY.

[From the Model American Courier.]

M'MAKIN—Sir: Seeing you had published quisite song of "Jeannette to Jeannot," I at you would like the answer also. I do now whether it has made a public appear-here yet or no, but it is THE song on the side of the water.

Yours, respectfully, E.

Answer to Jeannette.

heer up—cheer up—my own Jeannette.
Tho' far away I go,
I'll be the same Jeannot ;*
all the changes I may meet,
Ah ! be not so unkind,
and if I win both fame and gold,
o think I would forget you,
And the home I leave behind.

here's not a lady in the land,
ould win my heart from you, Jeannette,
Chance hath cast the lot on me,
So true as you have been.
hey must have gallant warriors,
ut mind you this, the soldier, love,
There'd be an end to war.

hy, ever since the world began,
The surest road to fame,
as been the field where men unknown
May win themselves a name :
nd if she were a Queen,
Have ever brighter shone,
hen looking on some warrior bold,
Returned from battles won.

nd would you put an end to deeds,
That ladies love so well,
nd have no tales of valor left,
For history to tell?
he soldier's is a noble trade,
then rail no more,
ero only KINGS allowed to fight,
There'd be an end to war.

nounced Jeanno.

SELECT STORY.

Captain Positive.

"I said so. Good by, Jobin, and make haste."

Boys, I don't know how it was, but I felt two tears freezing on my cheeks.

"No, captain," cried I, " I won't leave you ; either you shall come with me, or I stay with you."

"I forbid you staying."

"Captain, you might just as well forbid a woman talking."

"If I escape, I'll punish you severely."

"You may place me under arrest then ; but just now, you must let me do as I please, captain."

"You're an insolent fellow !"

"Very likely, captain ; but you must come with me."

He bit his lips with anger, but said no more ; I raised him, and placed his body across my shoulders, like a sack.

You may easily imagine that, while bearing such a burthen, I could not move as quickly as my comrades. Indeed, I soon lost sight of their columns, and perceived nothing but the silent, white plain around me. I moved on, and presently there appeared a band of Cossacks galloping towards me, with their lances in rest, and shouting their fiendish war-cry.

The captain was, by this time, in a state of total unconsciousness, and I resolved, cost what it might, not to abandon him. I laid him on the ground, covered him with snow, and then crept under a heap of my dead comrades, leaving, however, my eye at liberty.

Soon the Cossacks reached us, and began striking with their lances right and left, while their horses trampled the bodies.

Presently one of those rude beasts placed his hoof upon my left arm, and crushed it in pieces.

Boys, I did not say a word ; I did not move, save to thrust my right hand into my mouth, to keep down the cry of torture ; and in a few moments more the Cossacks dispersed.

When the last of them had ridden off, I crept out, and managed to disinter the captain. He showed few signs of life :

The Marriage Covenant in Olden Time.

The following is said to be a transcript of the marriage covenant, used by a clergyman of Boston, a century since. In reading it, one is forcibly struck with the delicate distinction made between the man and the woman, in their separate vows and also with the peculiar solemnity attached to the promise by the phrasing of the fourth paragraph :

"You, the Bridegroom and the Bride, who now present yourselves Candidates of the Covenant of God and of your marriage, before Him, in Token of your Consenting Affections and United Hearts, please to give your Hands to one another.

"Mr. Bridegroom, the Person you now take by the Hand, you receive to be your married Wife : you promise to love her, to honor her, to support her, and in all things to treat her as now, or shall hereafter be, convinced is by the Laws of Christ made your Duty. A tender Husband, with unspotted Fidelity, till Death shall separate you.

"Mrs. Bride, the Person you now hold by the Hand, you accept to be your married Husband : you promise to love him, to honor him, to submit to him, and in all things to treat him as you are now, or shall hereafter be, convinced is by the Laws of Christ made your Duty. An affectionate Wife, with inviolable Loyalty, till Death shall separate you.

"This Solemn Covenant you make, and in this sacred oath bind your soul in the presence of the Great God, and before these Witnesses.

"I then declare you to be Husband and Wife, regularly married according to the Laws of God and the King ; therefore, what God hath thus joined together, let no man put asunder."

A RAILROAD SOUTH.—A writer in the N. O. Delta who ventured to take a trip on the railroad to Baton Rouge, humorously describes his hair breadth escapes from a thousand and one dangers. We extract the following description of a "snake-head" so frequently met with on

LADIES' DEPARTMENT!

[Written for the Burlington Advertiser.]

Inter Nos.—To L**.

Since first I saw thee, dearest L ..,
There's a light upon my soul ;
And a secret wish within my heart,
I cannot well control.

There's a purity in my thoughts, L .. ,
That never used to be ;
And this sweet and holy feeling,
I attribute all to thee.

I ne'er look on a flower, now,
With petals fresh and fair ;
But what it has a tongue to speak
How pure thy young thoughts are.

I ne'er walk out at eventide,
When stars are in the sky ;
But what I think of one on earth,
As pure as those on high.

And when some beauteous, twinkling gem
Attracts my gaze awhile ;
I liken it to thee, dear L .. ,
And revel in its smile.

And I often wish that thou wouldst be
The star to light my way
Through life's uncertain, devious track,
To realms of purer day.

With such an angel guard as thou,
My pathway to attend ;
My life would be a vale of flowers,
And pleasures without end.

Boone County, Ky., Oct., 1849. SELMA.

PICKLES.—Do not keep pickles in common earthen-ware, as the glazing contains lead, and combines with the vinegar.—Keep pickles only in stone ware. Any thing that has held grease will spoil pickles.

Vinegar for pickling should be sharp, but not the sharpest kind, as it injures the pickles. If you use copper, bell-metal, or brass vessels for pickling, never allow the vinegar to cool in them, as it is then poisonous. Add a table spoonful of alum, and a teacup of salt to each three gallons of vinegar, and tie up a bag with

CHOICE S

In youth study, pose, in old age correct.

A QUANDARY.—A bar in the dough up to his in the leg of his trouser

THE LAST—AND WORS couple of boys going church like a celebrated cause they go two, two,

A QUEER CUSTOMER. matches?" asked a w "Oh, yes—all kinds," "Then I'll take a trotti

A ROYAL CENTIPEDE. mursy's sake. do tell has Qneyn Victory got are talking about "F Foot !" Yours, Ann P

THE CORONER'S FRI best friend," said Mr. "it brings me one th year; more than that, than ten thousand dea gin in London only, wl

WHAT IS A COQUETT of more beauty than se plishments than learn of person than graces mirers than friends ; men for attendants.

HORRIBLE.—Mr. C Castine, Me., in a par cut the throat of his y then attempted to cut prevented from effecti The child is dead—the will recover.—Balt. C

PLEASANT, VERY.—1 son to realize the follo To feel in dreams the kiss ing,
And see her blush again To wake well pleased fror

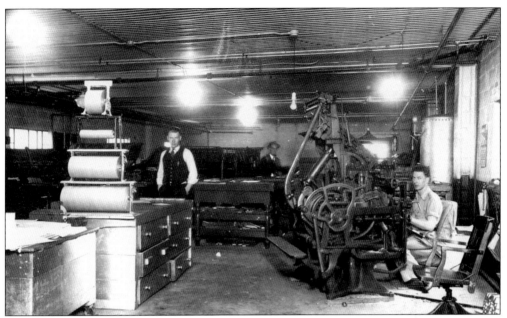

This interior view of the *Boone County Recorder* from about 1940 shows, from left to right, editor and publisher A.E. "Pete" Stephens, Albert Weaver, and typesetter Raymond "Ty" Combs. The *Boone County Recorder* has been the voice of the local community since it was established in 1875. Now owned and distributed by the *Community Recorder* group of newspapers, the weekly publication is still the official paper of Boone County.

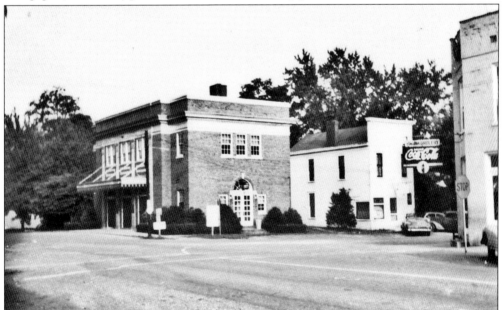

This *c.* 1950 photograph was taken from in front of the Burlington Hardware Store looking southeast across the intersection of Washington and Jefferson Streets. The 1924 Boone County Deposit Bank building sits on one corner, and Smith's Grocery anchors the other. The white-frame building is the original *Boone County Recorder* office built in the late 19th century. After the *Recorder* moved out, the first-floor space housed a shoe-repair shop.

With $20,000 capital stock in hand, the directors of a proposed new Burlington bank met at the courthouse in 1905 and agreed to construct the Peoples Deposit Bank on a lot at the corner of Jefferson Street and Union Square. The bank opened on November 5, 1905, with A.B. Renaker as cashier. At that time, the bank cashier was the sole employee and was expected to do everything, including janitorial work. By the mid-1920s, the bank's directors had purchased the adjacent Central House building with plans to demolish it and "erect a modern one story monumental type stone faced bank building." The Boone County Deposit Bank's new building had opened just two years before, and their directors felt that Burlington could not support two large banks. They offered to sell their building and assets and merge with Peoples Deposit Bank. In January 1927, the Peoples Deposit Bank moved from Jefferson Street into the building across from the courthouse. The Farmers Mutual Fire Insurance Company went into the 1905 building and occupied it until early 2004.

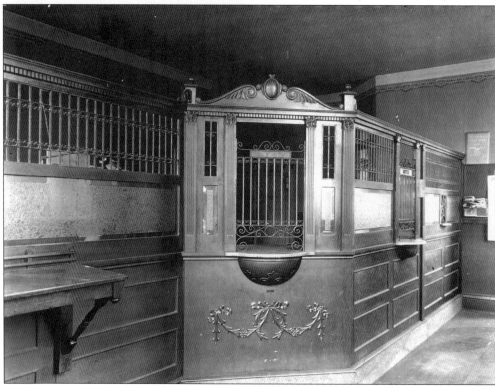

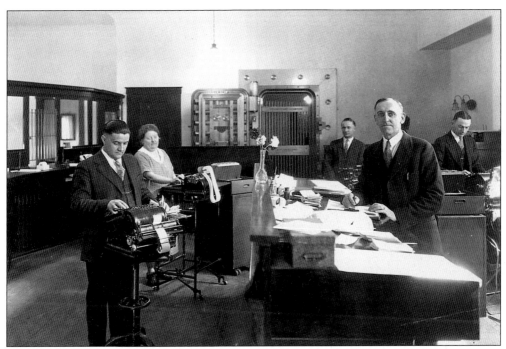

These photographs show the interior of the Boone County Deposit Bank shortly after it was completed in 1925. Pictured in the above image are, from left to right, L.C. Beemon, Miss Nell H. Martin, Galen S. Kelly, A.B. Renaker, and Carroll L. Cropper, who later became Boone County judge-executive. The bank operated in the same location at the intersection of Washington and Jefferson Streets until 1990, when the Boone County Planning Commission moved into the building.

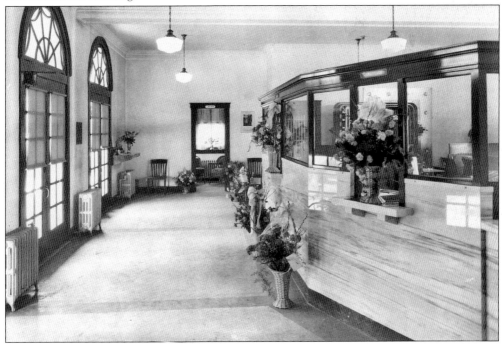

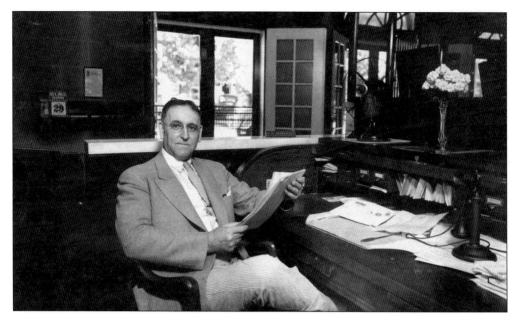

Alvin Boyers Renaker, known as A.B., grew up in Grant County but later moved to Burlington. In 1905, Renaker was chosen as cashier of the Peoples Deposit Bank in Burlington with a monthly salary of $70. Besides serving as community banker, Alvin Boyers Renaker was an important community figure who secretly supported the "Santa Claus Fund" and established a perpetual-care fund for the long-neglected Old Burlington Cemetery.

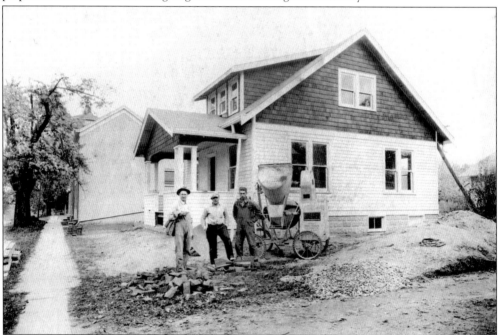

Boone County clerk Asa McMullen owned his own construction company and built houses in and around Burlington. This 1929 picture shows McMullen and his crew in front of a bungalow they built on North Jefferson Street. The building today looks very much like it did when completed, although it now houses the offices of a local tax attorney.

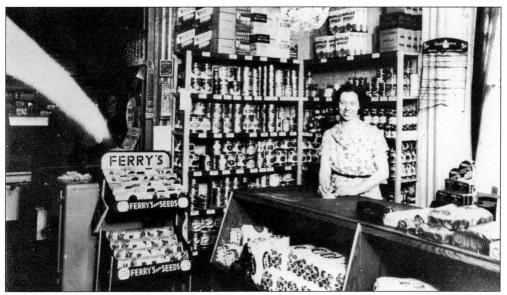

Before the Smith family bought the old Rouse-Blythe store on the southwest corner of Washington Street (Burlington Pike) and Jefferson Street, they operated their grocery store on the first floor of the 1830s Johnson-Buckner House on North Jefferson Street. In this 1939 photograph, Lucille (Rice) Smith poses behind the counter in the dry-goods room. Meats and cheeses were sold from the back room of the two-room store. Ironically, the other general store in town (Gulley-Pettit) also operated out of a house before moving into a storefront on South Jefferson Street.

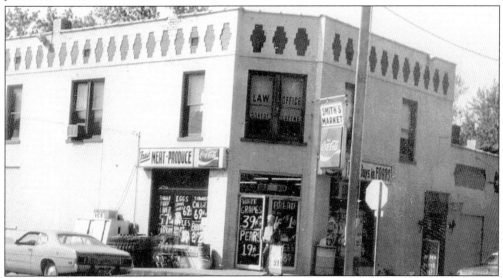

At the end of the Civil War, Dudley Rouse opened a general store in a two-story wooden building at the southwest corner of Burlington Pike and Jefferson Street (East Bend Road). Rouse was in business until the late 1890s. The shop was then run by Riddell and Crisler for about 25 years before Rouse's nephew Dudley Rouse Blythe bought it in 1921. The original wood structure burned that year, and Blythe immediately rebuilt it. Shown here about 1970 after the Smith family acquired the store, the "corner store" was a well-known Burlington landmark until it was demolished in 2002.

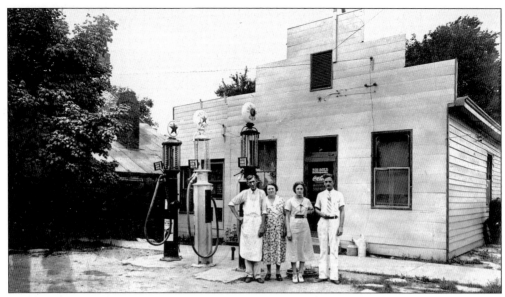

Gulley and Pettit's Store on South Jefferson Street supplied the needs of Burlington and surrounding areas. Established at the end of World War I, the store was owned by brothers-in-law Lester Gulley and Albert Pettit. Their store carried groceries as well as hardware and farm supplies. The owners were generous and often allowed farmers to buy their goods on credit until their tobacco crops were sold. Shown in front of the store in this c. 1930 photograph are, from left to right, Lester Gulley, Pearl Gulley, Laura Pettit, and either Stanley Ryle or Jim Ogden.

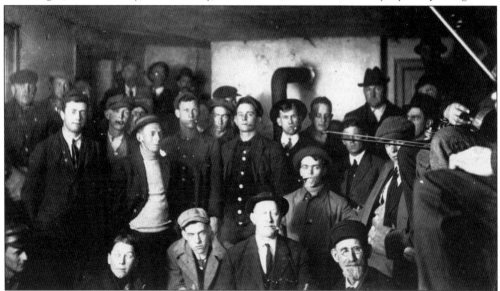

The back room at Gulley's Store was a destination for a portion of Burlington's male population, who gathered on Saturday afternoons to listen to the local band. Pictured in this c. 1920 photograph are, from left to right, (front row) Grover Gerald, Virgil Gaines, Garnet Tolen, Billy Cropper, and George Blythe; (middle row) ? Cason, Albert Clore, Russell Smith (smoking pipe), ? Kirkpatrick, Earl Garnet, Jack Eddins (white buttons), Doug Blythe, Shorty Gaines, Newton Sullivan, and Frank Button; (back row) Frank Rouse, Elmer Fowler, unidentified, Jude Riddell, Jeff Eddins, and Stanley "Boss" Eddins.

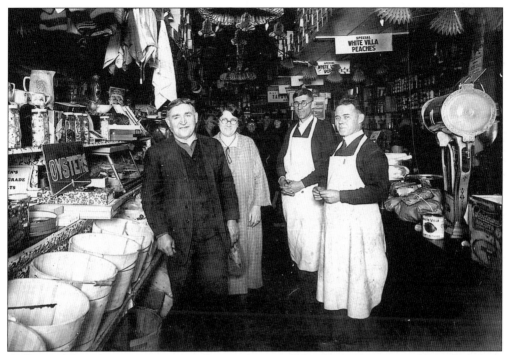

Gulley and Pettit's store was a typical general store of the day, carrying everything from knit caps to White Villa peaches and peas. Above, from left to right, Morris Riddell, Pearl Gulley, Lester Gulley, and Newton Sullivan (clerk) pose in a December 27, 1926 photograph. Pictured below on March 30, 1940, are, from left to right, Sam Ryle (truck driver), Lester Gulley, Pearl Gulley, Alberta Pettit-Robinson, and Wilber "Buss" Dennison (clerk).

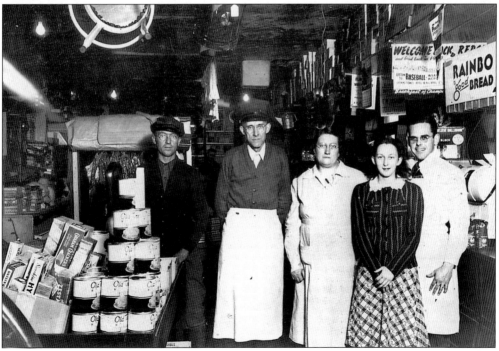

The Central House may be the most photographed building in Burlington, thanks to its location on a prominent corner. The structure was built about 1840 with Federal-period details such as the stepped-roof parapet on the south side. The building operated as a tavern for much of the 19th century and then as Clutterbuck's General Store, but it is remembered best as Burlington Hardware. *Boone County Recorder* owner Pete Stephens bought the property in 1940 and made it into the Burlington Hardware and Dry Goods Store. It remained a hardware store until 2002. In 2003, the Central House was restored as the County Seat Restaurant by the Roscoe Group, descendants of Mr. Stephens.

Located in the old Central House Hotel, Clutterbuck Brothers was owned and operated by Homer and Roy Clutterbuck. This bill to the county, dated January 4, 1901, lists among other things a comb and soap for the jail, one lamp complete, a half-gallon of oil, and pen points. Besides offering a wide variety of merchandise such as dry goods, notions, boots, and shoes, the brothers' store was also a social gathering place. Chairs and boxes surrounded the store's stove where the locals gathered to warm themselves and exchange news. One of the topics covered was certainly baseball, as both Roy and Homer were avid players.

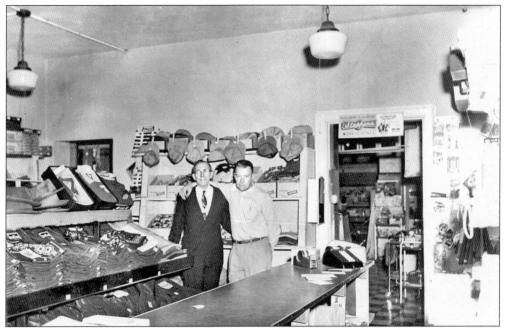

In this *c.* 1950 photograph, Lee McNeely (left) and Pete Stephens pose in the men's dry-goods and clothes department of the old Burlington Hardware and Dry Goods Store. The shop was a true department store, with separate rooms and sales counters throughout the building. This room has been remodeled and is now an ice-cream parlor and sandwich shop.

Lee McNeely is seen here in the paint room of the Burlington Hardware and Dry Goods Store. Housewares, clothing, and appliances were later phased out when the building changed hands. As Burlington Pro Hardware, paint remained one of the seemingly endless number of items and services available until the shop closed in 2002.

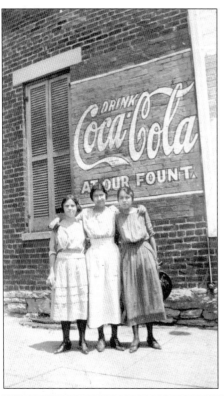

The caption on this 1919 photograph reads simply "Chums." Posing together by the side of the Burlington Hardware Store are Rosa McMullen (center) and two friends. Perhaps they have just completed their day at Burlington High School and are stopping for a Coca-Cola at the store's fountain.

This snowy, *c.* 1900 photograph was taken looking south on Jefferson Street (East Bend Road) from the center of town. The first *Boone County Recorder* building stands on the left with the Johnson-Buckner House immediately beyond. Houses occupied by the Poston and Pettit families are on the right, as is the Gulley Store building. None of the buildings remain today.

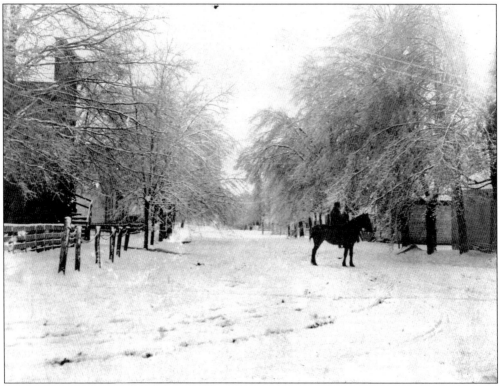

Four

PEOPLE AND EVENTS

Community Leaders, Hangouts, and Happenings

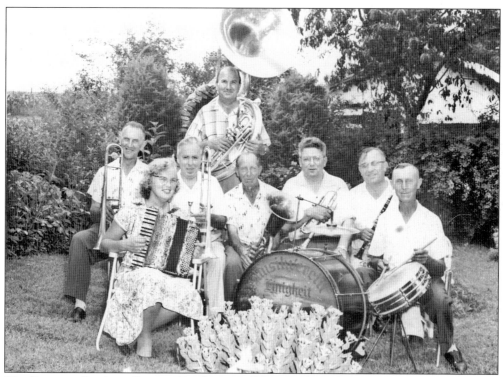

The Boitman Brothers German Band was well-known throughout Burlington and northern Kentucky. Pictured here as they break from practice on the family farm are, from left to right, Aloysius Boitman, Betty Boitman Poole, Eddie Koch, Michael Wild, Ben Boitman, Ernst Macke, August Boitman, and Gregor Boitman. The band played for numerous church festivals and receptions throughout the area.

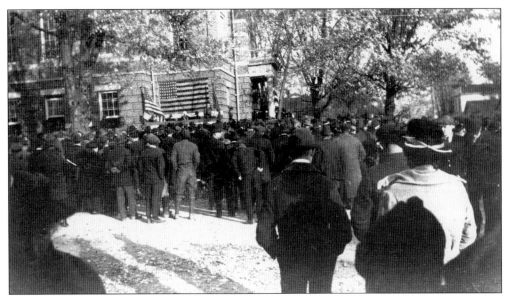

On Armistice Day in 1920, a plaque honoring the Boone County men killed in World War I was dedicated. Ceremonies that day included a band, speeches, and a parade of veterans. Included among the veterans was 80-year-old Elijah Parker, wearing his Confederate gray uniform. The speakers' platform was constructed outside the county sheriff's office. The plaque was donated by the Boone County chapter of the American Red Cross.

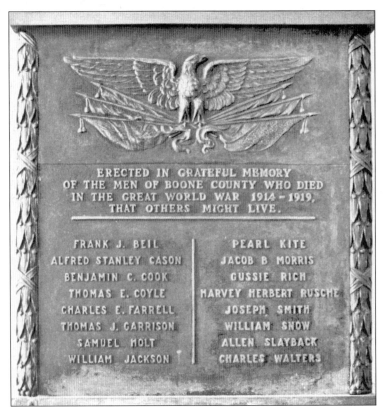

ERECTED IN GRATEFUL MEMORY
OF THE MEN OF BOONE COUNTY WHO DIED
IN THE GREAT WORLD WAR 1914 – 1919,
THAT OTHERS MIGHT LIVE.

FRANK J. BEIL	PEARL KITE
ALFRED STANLEY CASON	JACOB B MORRIS
BENJAMIN C. COOK	GUSSIE RICH
THOMAS E. COYLE	HARVEY HERBERT RUSCHE
CHARLES E. FARRELL	JOSEPH SMITH
THOMAS J. GARRISON	WILLIAM SNOW
SAMUEL HOLT	ALLEN SLAYBACK
WILLIAM JACKSON	CHARLES WALTERS

The plaque honoring Boone Countians who gave their lives during World War I is prominently displayed in the first-floor hallway of the 1889 courthouse.

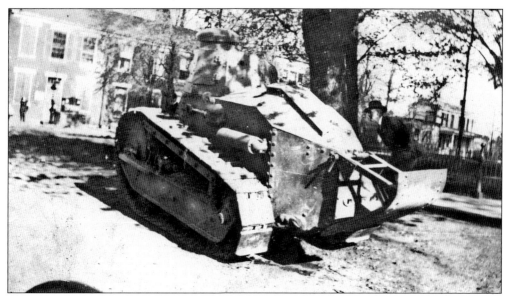

A curious Burlington citizen inspects a World War I tank parked in front of the courthouse in 1919. In the background, across Jefferson Street to the left, is the easily recognized Central House building, which now houses the County Seat Restaurant. The large two-story white house to the right was the home of Dr. M.A. Yelton. Directly behind the tank (not seen in the picture) was the courthouse cistern, the source of public drinking water. A tin cup hung on the cistern for all to use.

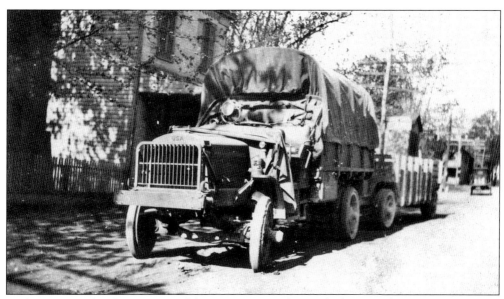

In this picture, dated 1919, a World War I army truck is parked on Washington Street facing east in front of what is now the Little Place Restaurant. Just behind the truck is the Boone County jail. Although traffic was light, the truck and the car in the background show that Burlington and the county were well on their way in the transition from horse-drawn vehicles to automobiles.

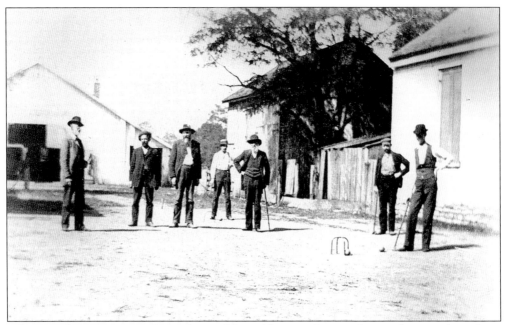

When gentlemen weren't solving the world's problems in the courthouse, they may have been tangled in a croquet match, which was a common Burlington pastime. This c. 1900 photograph shows a group of "strikers" playing on the town's unofficial court laid out on Union Square west of North Jefferson Street. The white building on the right is the Joseph Graves House, which may date as early as 1817. In 2002, it was rehabilitated as CoCo's Sandwich Shoppe.

One of Burlington's favorite sons, Albert "Sickem" Weaver, poses on Washington Street in the early 1920s. Weaver grew up in Burlington, worked for the *Boone County Recorder*, and was very active in civic and community events. He was an ordained Baptist minister, a deacon at Burlington Baptist Church, and also a highly honored 33rd degree Mason.

This undated postcard takes an unusual approach to advertising Burlington.

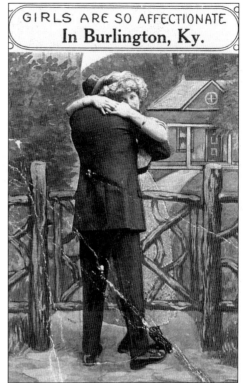

GIRLS ARE SO AFFECTIONATE
In Burlington, Ky.

Leonard "Jack" Eddins poses with one of his horses in front of the Central House Hotel about 1915. Although Jack and brother Boss Eddins operated the first automobile repair shop in Burlington, horses were still a prevalent means of transportation. A mounting block, essentially a stairway used for reaching carriages or wagons, was still present in front of the hotel. An exterior stairway to the second floor of the hotel is also visible at left in this picture.

William Honesty "Onnie" Rouse, pictured with his wife, Addie, was a well-known farmer and stock breeder in Burlington at the beginning of the 20th century. He was especially known for his short-horn cattle, Poland China hogs, and flocks of sheep. He also operated the Burlington Saw and Grist Mill. Onnie grew up in the Limaburg area where he was a member of the Limaburg Brass Band in the early 1890s.

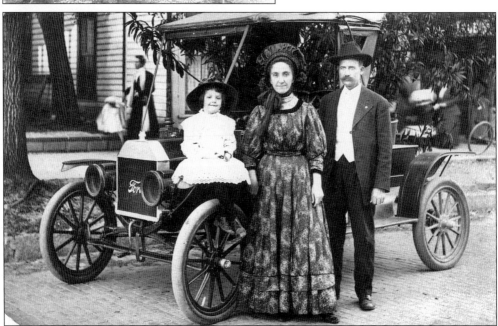

Dr. William O. Rouse, seen here with his wife, Katherine, and daughter, Rachel, grew up in Limaburg, where his father, Jacob, and uncle, Silas, ran the general store. After attending Wittenburg University and completing his studies to become a physician, he returned to Boone County and practiced medicine in the early 20th century. He later moved to North Carolina where he died in the early 1940s.

Dr. M.A. Yelton and his wife, Alice, were a well-known Burlington couple. During the hard times of the Depression, Dr. Yelton could be counted on to make house calls at any time of day or night to attend to the sick, often taking farm produce as payment. In this photograph, the Yeltons are seen on North Jefferson Street in Burlington. The old Burlington Presbyterian Church, which now houses the Boone County Maintenance Department, is seen in the background.

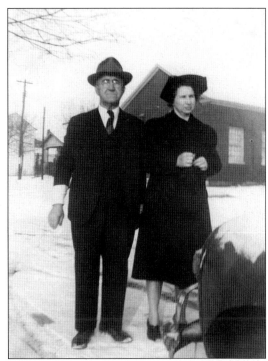

Ralph V. Lents and his wife, Molly, are shown here at a 1965 party hosted by William and Anne Fitzgerald. Ralph Lents was an educator in Boone County for over 40 years. He taught at Constance and Florence Elementary Schools as well as Boone County High. Mr. Lents was the advertising director of the Boone County Fair for 51 years and was affectionately known as "Mr. Boone County Fair." After his 1984 death, he left $500,000 to the Boone County Public Library District. The money was used to build the Lents branch on North Bend Road, completed in 1989.

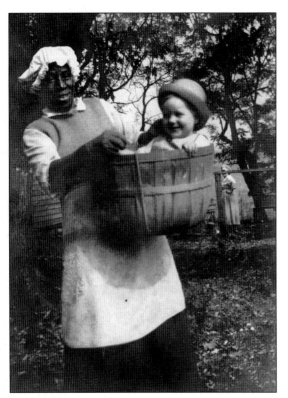

Aunt Lizie is pictured here in 1924 on the John Stephens Farm. Aunt Lizie, like many African Americans in rural Boone County, worked on a farm. Here she holds a basket with Harold Williams as a small child. Aunt Lizie lived on the farm in one of four former slave houses and helped with various household chores. She was paid in kind with goods such as produce. The old tool house on the farm is seen in the background, which stands in front of the creek where clothes were once washed. Aunt Lizie helped deliver Glenrose Williams, the only female sheriff in Boone County history.

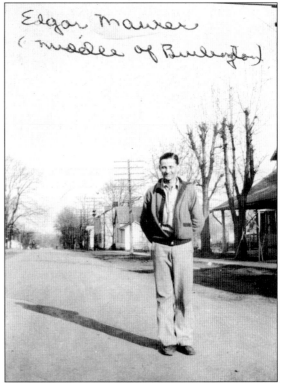

In this c. 1940 photograph, Edgar Maurer stands in the middle of a traffic-free Washington Street (Burlington Pike). The house to the right was the home of Nora Weaver and is presently part of the Kentucky Farm Bureau offices. In the background stands the exchange building. Mr. Maurer was a long-time road supervisor for the Boone County Road Department.

70

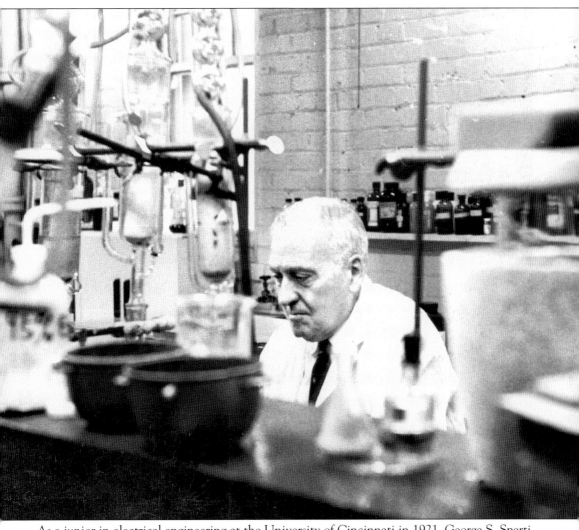

As a junior in electrical engineering at the University of Cincinnati in 1921, George S. Sperti developed the KVA meter, which for the first time allowed accurate measurement of the massive quantities of electricity consumed by large industries. Despite lucrative job offers, Sperti stayed at the university after graduation and co-founded the Basic Research Laboratory. There, he discovered the ultraviolet wavelengths that make Vitamin D and registered numerous patents, including the sunlamp. In 1935, Sperti left the university and established the Institutum Divi Thomae, a combined research laboratory and graduate school. While conducting research on cancer, Sperti developed several biodyne products, including Sperti Ointment for burns and Preparation H. In the late 1930s, Dr. Sperti began buying farmland south of Burlington. Eventually, his Boontucky Farm reached 600 acres and gained national recognition for champion cattle. Dr. Sperti conducted a range of experiments on the farm, many of them using mice raised in a building that locals called the "mouse house." Dr. Sperti died in 1991. Today, the most rugged part of Boontucky Farm forms the heart of Gunpowder Creek Nature Park.

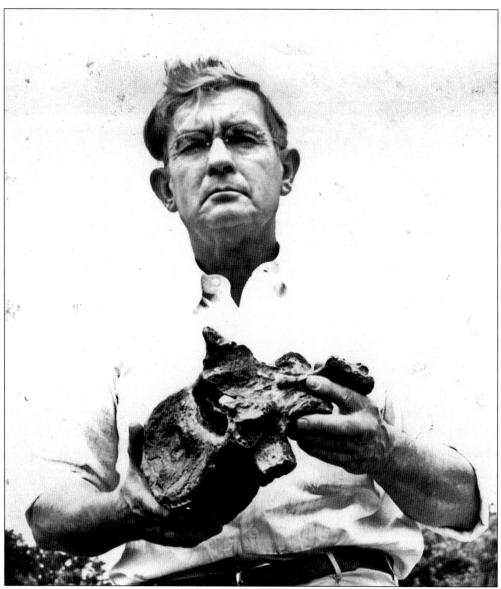

William Fitzgerald is often recalled as Boone County's foremost historian. William and his wife, Anne, moved to Boone County in 1938 when he was hired as a printing instructor at Holmes High School in Covington. While working for the Boone County clerk's office, Mr. Fitzgerald learned a great deal about the history of the county. His most significant contributions to Boone County history were the writing of historical articles and books and his work as secretary-treasurer of the Big Bone Lick Historical Association. The Fitzgeralds also worked with a dedicated group of people who walked the cemeteries of Boone County and copied all the names on the tombstones and compiled them into books. Fitzgerald was a prominent historian and genealogist of northern Kentucky, and on a state level he served as the president of the Kentucky Historical Society and later as the director of that society's library.

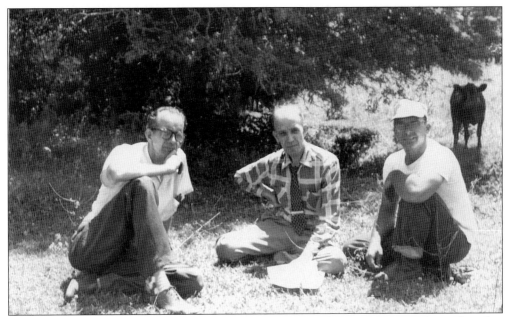

Pictured from left to right are Ellis Crawford, Clyde Jones, and Bruce Ferguson taking a breather during excavations at Big Bone Lick in 1955. Archaeologist Crawford (1905–1972) started the Behringer-Crawford Museum with collector William Behringer. Crawford headed numerous prehistoric excavations in Boone County. Clyde Jones was an amateur archaeologist from Grant County. At the time, Bruce Ferguson was president of the Big Bone Lick Historical Society, which was successful in its efforts to encourage Kentucky to create a state park.

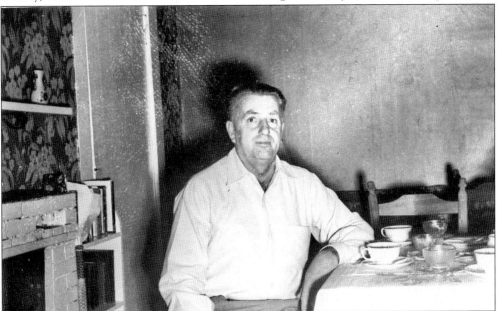

Long-time Boone County surveyor Noel Walton is shown here about 1960. A native of Rabbit Hash, Walton made many detailed surveys of Boone County. His large-scale map of the county depicting property owners is one of the most detailed maps ever made of Boone County. Walton was also an accomplished musician who played music at silent movies in Cincinnati.

Blinded in 1926 at the age of 13 when his and his friend's model cannon exploded, John Caldwell has lived in Burlington for 60 years. Although raised in Cincinnati, he says that he was destined to be a farmer. His family visited the Robert Chambers farm in Burlington on Easter Sunday, 1944. They bought the house the following Tuesday, and John has lived there ever since. The picture below, taken in 1960, shows John walking in front of the barns on the west side of East Bend Road, which bisected the 116-acre farm. At the time, he was managing the farm by himself, doing all of the work necessary to raise champion Brown Swiss cattle. He quit farming in 1965 and was appointed to head President Lyndon B. Johnson's Head Start program in Boone County, a position he kept for two years. He completed a Master of Community Planning degree from the University of Cincinnati in 1970. He then helped create the Dinsmore Homestead Foundation in 1986, at the request of his friend Martha Breasthead, who was the last Dinsmore to live in the Dinsmore House.

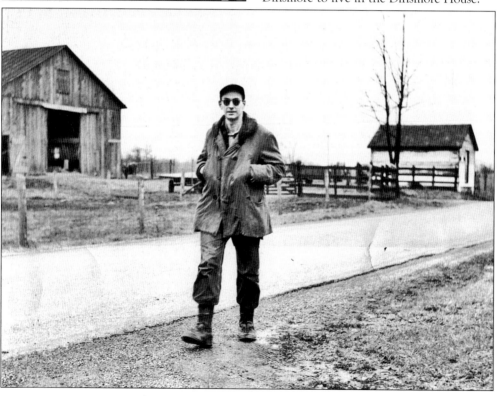

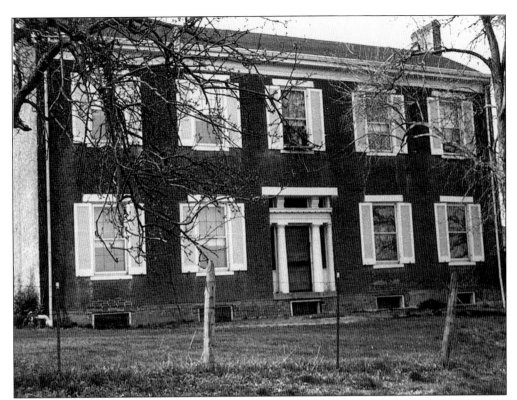

The Robert Chambers House on East Bend Road is one of the most spectacular Greek Revival residences in Boone County. The house was built for Robert Chambers between 1832 and 1836 by mason Jessie Kelly and master woodworker Thomas Zane Roberts Sr. Although seldom used, the elaborate north doorway represents the most academically correct use of the relatively sophisticated Greek Doric order in Boone County. The property has been in the Caldwell family since 1944.

Frank Walton was Boone County sheriff from 1938 to 1942. The office of sheriff was one of only two elected offices created by the first Kentucky constitution, in 1792. To this date, it is the only office in county government limited to a four-year term. Presently, the county sheriff has four major duties: law enforcement, tax collection, service to the courts, and election duties.

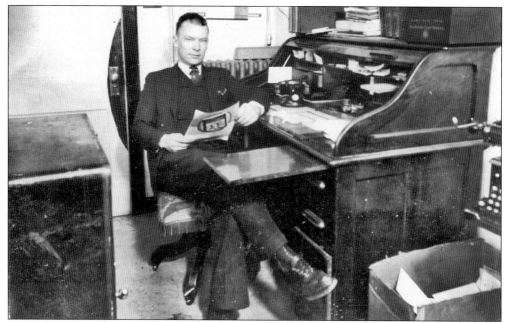

Born and raised in Burlington, A.E. "Pete" Stephens was one of Burlington's leading citizens and businessmen before his sudden death at the age of 47 in 1962. He purchased the *Boone County Recorder* newspaper in 1935 and developed it into one of the best small newspapers in Kentucky. In 1943, Stephens was instrumental in organizing the Burlington's first volunteer fire department and also served as its first fire chief. This *c.* 1940 photograph shows Mr. Stephens behind his desk at the *Boone County Recorder*.

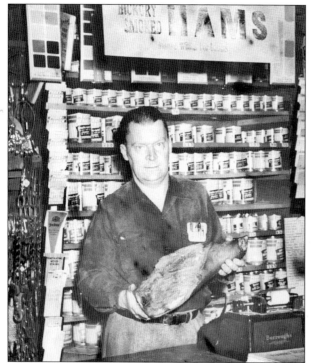

In 1940, Pete Stephens opened the Burlington Hardware and Dry Goods Store in the old Central House Hotel. In this late 1950s photograph, Stephens poses with one of the smoked hams sold through the shop. Mr. Stephens enjoyed the process of creating these specially smoked hams and took great pride in offering them to the public.

At right, Boone County sheriff John Talbot "Jake" Williams stands in front of the family home on Nicholas Street in Burlington in this 1943 picture. Below he is shown in 1918 as a serviceman in World War I. Born December 20, 1889, in Union, Kentucky, Williams was Boone County sheriff during the famous Kiger murder trial in 1943. He died suddenly in the Boone County Courthouse on September 6, 1944, and was succeeded by his daughter Glenrose Williams. The enormous stress of investigating the Kiger murders and managing the subsequent trial are thought to have contributed to J.T. Williams's early death. The Kiger case concerned the shooting deaths of Covington city commissioner Carl Kiger and his young son. Kiger's 16-year-old daughter Joan was accused of the crime but was acquitted on the grounds that she was sleepwalking and could not be held accountable for her actions.

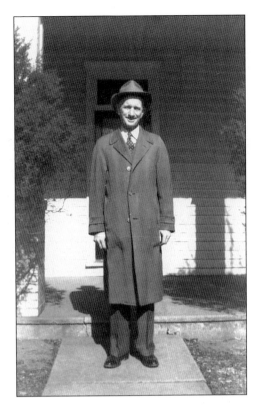

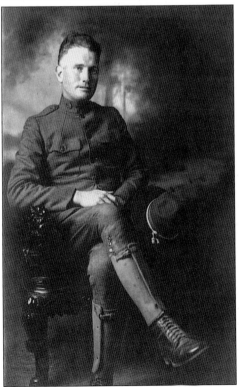

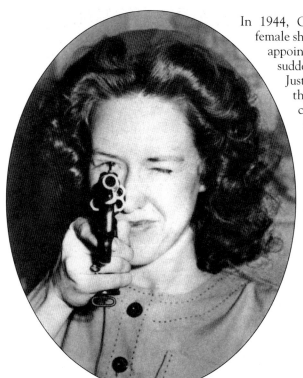

In 1944, Glenrose Williams became the first female sheriff in Kentucky when Judge Cropper appointed her to the position following the sudden death of her father, Jake Williams. Just 23 at the time of her appointment, the Hebron High School graduate carried out the law enforcement and tax collection duties of the sheriff's office for 15 months. This picture appeared in the *Cincinnati Enquirer Sunday Pictorial Magazine* on December 23, 1945. (Photograph courtesy of *Cincinnati Enquirer*.)

Sheriff Glenrose Williams poses in front of the courthouse stairs with two illegal slot machines confiscated from an illegal back room gambling hall in 1945. Glenrose was determined to uphold the law during her tenure as sheriff. On another occasion, she and one other trusted county official conducted a raid on a gambling operation set up by Chicago mobsters along the county line in Erlanger. Men fled the building as they approached, but they succeeded in shutting down the operation.

In 1938, Frank Sinton Milburn bought 50 acres on the north side of Burlington and constructed a concrete-block machine shop. Under various company names, he and his associate Henry Jenisch helped amateur inventors develop working models of their inventions. In 1947, Milburn began ghost-writing a weekly "Genius at Work" column in the *Cincinnati Enquirer*. A feature article in the June 1950 issue of *Popular Mechanics* generated over 30,000 letters and 500 visitors to his Burlington machine shop. Frank quickly accepted the *Cincinnati Post*'s offer to publish a weekly column called "The Invenoscope" under his own name. Frank's column gave practical advice to budding inventors and showcased real-life success stories. Through the mid-1950s, the Invenoscope and several nationally syndicated feature articles generated over 100,000 letters. Thousands of would-be inventors brought their ideas to Frank's shop in Burlington, which locals quickly pointed out was "over there behind town in a cornfield." (Photograph by George R. Hoxie.)

A 1931 graduate of the Ohio Mechanics Institute, Frank Milburn was a mechanical genius. Frank involved himself in activities ranging from amateur radio to song writing to photography and was very good at everything he did. Some of the finest photographs featured in *Images of America: Burlington* were taken by Frank Milburn and developed in his Ft. Mitchell darkroom. Dubbed the "Cornfield Edison" by *Mechanix Illustrated* Magazine, Milburn served as a technical consultant for the American military and over 70 industrial companies around the country. During World War II, his Burlington machine shop sub-contracted with the Gruen Watch Company to help manufacture the Norden bombsight, which was the United States's second-most closely guarded secret weapon of World War II. Periodically, Milburn would deliver a box of the finished pieces to Gruen's Time Hill complex in Cincinnati. He always made the deliveries at night and carried a sidearm with him in the car. (Photograph by Frank S. Milburn.)

Always a champion of the "little guy," Frank Milburn's long-term goal was to develop an institute in Burlington where inventors could vacation with their families (staying in cabins on site) and devote time to inventing. Over a span of several decades, he obtained hundreds of patents on behalf of budding inventors. In this *c.* 1950 image, Milburn meets with a prospective client in his Burlington office.

This 1952 photograph shows Frank Milburn on the set of his *Inventions for Sale* television show, which aired Sunday afternoons on Cincinnati's WCPO-TV. Frank wrote, produced, and directed the show but abandoned it after only 12 episodes to focus on his syndicated news columns, which reached many more individuals.

On March 2, 1948, Frank Milburn's phone went out, a widespread problem in the county at that time. The next day, Milburn visited the Consolidated Telephone Company's office in Florence to see what could be done. Finding no satisfaction in the company's response, Milburn and more than 50 others soon formed the Citizens Telephone Committee, which included Judge Carroll Cropper and other leading figures of the day. Milburn and the Dixie Camera Club of Florence photographed the poor condition of the phone lines and submitted the pictures to local newspapers with captions such as "Fix these conditions so we can't photograph them." This picture was taken looking east along Burlington Pike at Camp Ernst Road. The battle between Consolidated and the committee intensified and in November 1950, Boone County, the Cities of Florence and Walton, and 501 individuals petitioned the Public Service Commission of Kentucky. Telephone service in Boone County was soon upgraded.

Sarah Madge Dickerson, shown here in 1932, died of rheumatic fever in 1935. Rheumatic fever was one of the number-one killers of school-aged children in the early part of the 20th century. Note that Madge is wearing an "FDR for President" pin.

An exasperated Betty Poole seems to say, "That's my little brother!" in this c. 1942 picture. Their uncle Gregor Boitman of Burlington was one of many young men drafted during World War II. While stationed in Texas, he sent home presents to his niece and nephew, Betty and Aloysius. Taken at the side of the family home, Betty shows off her new dress while younger brother Aloysius draws his new toy cowboy gun from its holster. Sadly, young Aloysius died just a few years later of a burst appendix.

Seen here on the cover of the February 1969 *Cincinnati Telephone Bulletin* is Covington native Caroline Williams, whose pen-and-ink drawings of the Cincinnati area were an important element in the artistic heritage of Cincinnati and northern Kentucky. Her first work appeared in the *Cincinnati Enquirer* in 1932. As a staff artist at the *Enquirer*, she provided pen-and-ink sketches for the editorial page of the Sunday edition, and for 47 years, her weekly *Spot in Cincinnati* drawings were a regular feature. In 1945, she moved to the c. 1800 O. Miner Log House one mile west of Burlington to become a freelance artist. Over her career, Ms. Williams published collections of her sketches and volumes of poetry, one of which was printed in her own on-site publishing house, Penandhoe Press, named after her beloved log home. Caroline Williams died in 1988, and the log house and immediately adjacent property were given to the Dinsmore Homestead Foundation. The log house has since been dismantled and is stored on the Dinsmore property.

Herb Cress and Bob Ellis pose in front of Calvin Cress and Sons farm equipment shop that stood at the intersection of Camp Ernst Road and the Burlington-Florence Pike (Highway 18). The Cresses were honored in 1956, 1957, and 1958 with a conservation award for their outstanding cooperation with the conservation district. W. Robert Ellis also left a lasting legacy with the conservation district. Born in an industrial Midlands section of England, Bob Ellis came to the United States as a young boy in 1907 and moved to Boone County in 1941. He was Boone County correspondent for the *Cincinnati Enquirer* for 19 years and devoted 35 years to the Boone County Conservation District. Mr. Ellis willed his home, modeled on George Washington's Mount Vernon, to the National Foundation of Homemakers. The house is now part of the Ellis Cooperative Extension Center complex, built on three-and-a-half acres donated by Ellis in the 1980s.

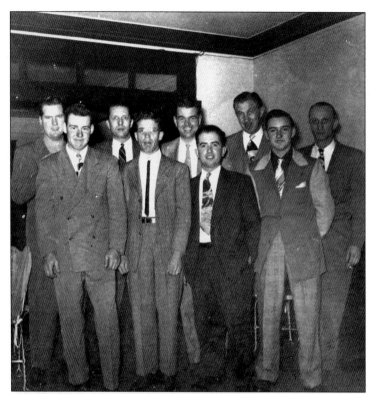

Members of the Boone County Aero Club pose in this 1947 photo. Pictured are, from left to right, (front row) Melvin Elslanger, unidentified, Willie Johnson, and Raymond Earl Maddox; (back row) Harold Williams, unidentified, John Randall, Bob ?, and Ben Johnson. The Aero Club was formed in 1946. Boone County Airlines Inc., at the fledgling Boone County Airport, had three planes that the Aero Club used for recreational purposes. The club also flew from a small airstrip on Elslanger's farm just north of Conrad Lane.

The Boone County Aero Club did more than get together to fly planes. This 1948 photograph shows them enjoying a pig roast at the Standard Oil Products hangar at the Boone County Airport. The club disbanded in the early 1950s. Some members, including Melvin Elslanger, later piloted corporate planes for Proctor & Gamble.

This photograph depicts the first-ever 4H and Utopia Club Variety Show held in Kentucky. Joe Claxon, the tall man standing in the back at right, was a Boone County agriculture agent for 28 years and is credited with organizing this historic event. The other man in the photograph is Joe Rouse, who was also associated with the agricultural extension program. No one else in the photograph has been identified. The shows were recorded on the stages of the Burlington, New Haven, and Florence schools.

Joe Claxon Jr. served as the Boone County agriculture agent from 1952 until his retirement in 1980. In 1957, he received the National Distinguished Service Award for County Agricultural Agent. Mr. Claxon had a television garden program on WLWT in the 1970s, as well as a newspaper column called "Joe Claxon's Half Acre." On top of his serving on the Boone County Fair Association Board, he also was the only person ever to serve as both president and chairman of the Kentucky State Fair Board. In this picture, he is participating in an annual event where he would present outstanding achievement awards to participants of the Future Farmers of America and the 4-H Club. The young girl in the photo is unidentified.

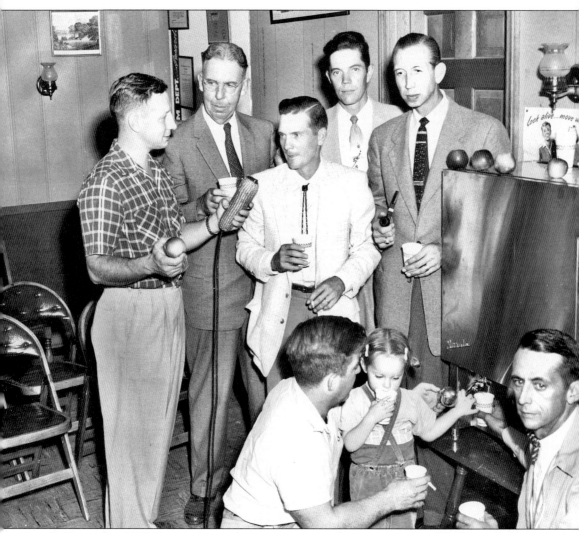

In November 1956, Boone County farmers were invited to appear on the WLW national radio program "Everybody's Farm." The program, which began in 1941, was broadcast from WLW's 700-acre farm located in Mason, Ohio. Notice the corncob microphone. Pictured are, from left to right, (in front) John Conner (manager of the farm), his daughter, and J. Lassing Huey; (standing) WLW radio host Bob Miller, unidentified, L.M. Moore Jr., Bill Graves, and Joe Claxon Jr.

In this late-1950s photograph, Boone County agriculture agent Joe Claxon Jr. is dressed as Colonel Sanders at an exhibit booth. The promotion was meant to convince the National Association of County Agricultural Agents to have their next convention in Kentucky and it worked. Only one other person in this photograph is identified. Chester Brown, who also served as a Boone County agricultural agent, is standing behind the counter to the immediate right of the woman.

On May 3, 1941, Harold Williams photographed his friends just before they piled into two cars for a road trip to Churchill Downs. Pictured are, from left to right, Jim Bullock, Bob Garnett, J.D. Riddell, and John Randall. The boys were in for a special treat that day in Louisville, as they saw jockey Eddie Arcaro guide fiery Whirlaway to a come-from-behind win of the 67th Kentucky Derby. Whirlaway subsequently ran away with the Preakness Stakes and Belmont Stakes to become the fifth Triple Crown winner.

The Burlington Grill was located across the street from the courthouse, where the Little Place Restaurant stands today. In this picture from the early 1950s, Sherry Holbrook stands in front of the restaurant dressed for Halloween. Sherry was a student at Burlington High School. The school's last graduating class was in 1954, before Burlington High was consolidated with the county's three other high schools to form Boone County High School.

This photograph appeared above the fold in the Monday, December 16, 1957, edition of the *Kentucky Enquirer* with the caption "Alvin Clore, left, and Cecil (Pie) Presser, Boone County's Jailer, finish the job of eviscerating three hogs." The picture was one of several documenting an old-fashioned community hog killing. Four Burlington farmers had gotten together the previous Saturday to slaughter and process five well-fed hogs. (Photograph courtesy of *Cincinnati Enquirer*.)

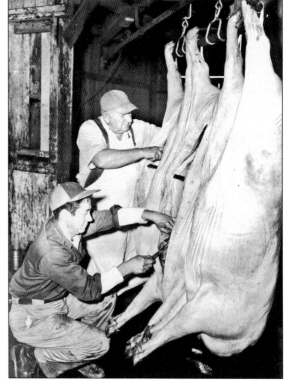

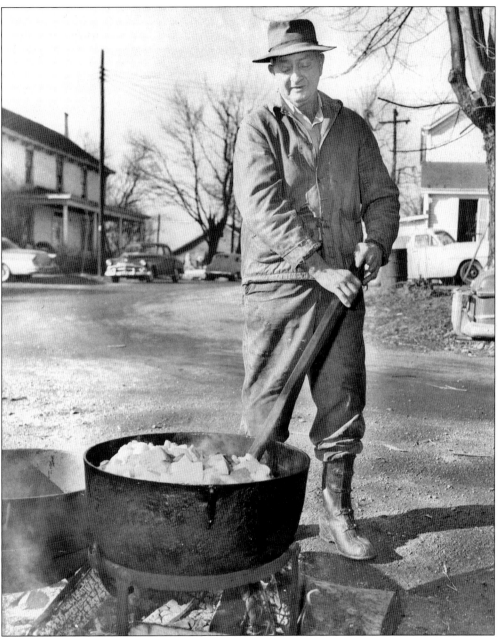

This picture of Alvin Clore was taken on Union Square behind what is now the Little Place Restaurant on December 14, 1957. After helping to slaughter the hogs, it was Clore's job to render the lard to make cracklings. A wide variety of other pork products were produced during the weekend community event, including sausage, head cheese, cured hams, tongue, spareribs, liver pudding, and tenderloin. Community slaughtering events like these were an efficient and economical way to process hogs, which required much skilled labor. The old timers lamented that this approach was rapidly being replaced by "locker plants and meat processors." (Photograph courtesy of *Cincinnati Enquirer*.)

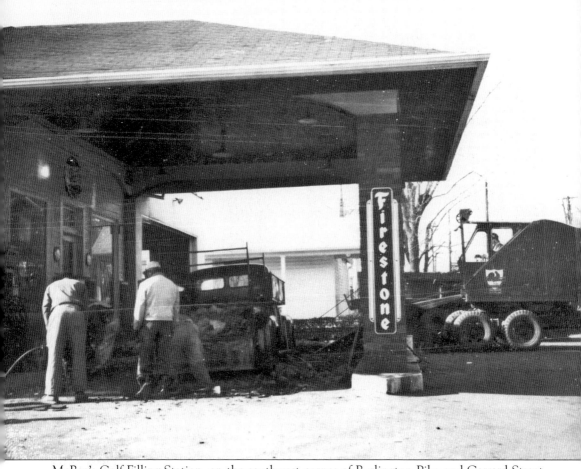

McBee's Gulf Filling Station, on the southwest corner of Burlington Pike and Garrard Street, was the "hub of Burlington" for 35 years. W.L. "Les" or "Mac" McBee opened the station in 1936 when gasoline was 17 cents a gallon; his wife Lois kept the books. Over the years McBee's grew into Burlington's "unofficial meeting and loafing place, its community center of sorts and its tourist information service." In the lobby stood a nine-inch, black-and-white television with a magnifying lens and about a dozen mis-matched kitchen chairs. When the men weren't watching Reds baseball, the kids watched Don Eagle wrestle or *Captain Video*. McBee's was demolished in 1971 to make way for the widening of Burlington Pike. This mid-1950s photograph shows work being done under the canopy at the station.

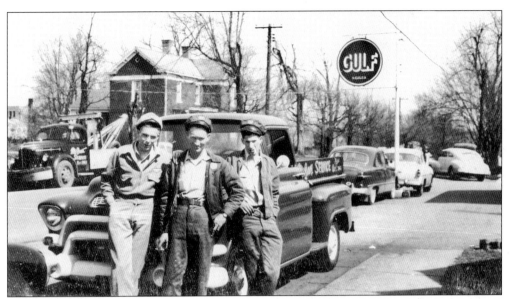

The employees of McBee's Gulf Service Station pose in front of one of the company trucks. Pictured from left to right in this c. 1955 photograph are Louis Feldhaus, Wendell "Jonesy" Jones, and Aubrey "Orb" Headon. Sen. S. Walker Tolin House stands in the immediate background.

Rev. Samuel S. Hill Jr. stands on the sidewalk in front of McBee's Gulf Filling Station on Washington Street in this c. 1954 photograph. A Virginia native, Reverend Hill led the Burlington Baptist congregation from 1953 to 1955. In the background is the 1889 courthouse, Mrs. Nell Martin's bungalow, and the home of Mr. and Mrs. Beemon, whose glider sat right on the street. The houses were demolished when the Boone County Administration Building was built in 1981.

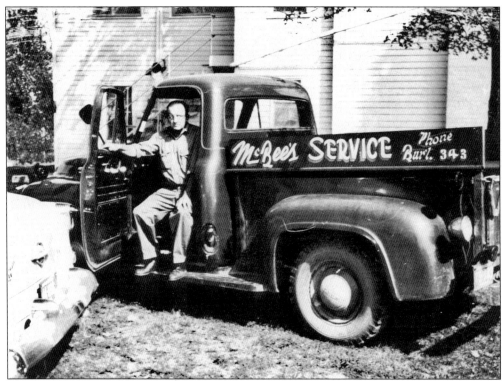

Les McBee was photographed *c.* 1954 getting out of one his trucks. This picture was taken next to the Stephens House, the white house that still stands at the northwest corner of Burlington Pike and Camp Ernst Road (Highway 237).

Bryon Kinman was Boone County sheriff from 1954 to 1958 and served as the first police chief of the Boone County Airport (1958 to 1976). Kinman is shown here in 1976 in his airport police chief uniform. One of Kinman's more unusual incidents on the job occurred when a plane was hijacked and diverted to the airport, while the hijacker held a passenger at knife-point. Upon arrival, Chief Kinman promptly boarded the airplane and disarmed the hijacker, ending the stand-off. Delta Airlines gave Kinman a $20 reward.

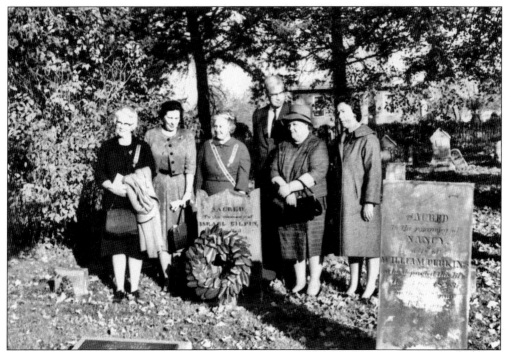

On the Fourth of July, 1834, Israel Gilpin died at the age of 94 and was buried in the Old Burlington Cemetery. One hundred and thirty years later, members of the local chapter of the Daughters of the American Revolution (DAR) gathered at his grave to honor this Revolutionary War veteran with a marker commemorating him and his service. Instrumental in this ceremony was Mrs. Florence Brothers, second from right, a member of the DAR and president of the Boone County Historical Society in the 1950s. Mrs. Brothers spent many hours collecting and writing about local history.

Mr. and Mrs. Wilford Scott stand behind their home on Dr. Sperti's Boontucky Farm south of Burlington. Mr. Scott worked as farm manager there for 18 years, helping to develop a nationally known herd of registered Holstein cattle, including the all-American Holstein bull known as the Boontuck Ormsby bull. Through judging many dairy shows throughout Kentucky, Mr. Scott became known as an outstanding dairy cattle judge. He also served as president of the Northern Kentucky Holstein Cattle Club and the Boone County Farm Bureau.

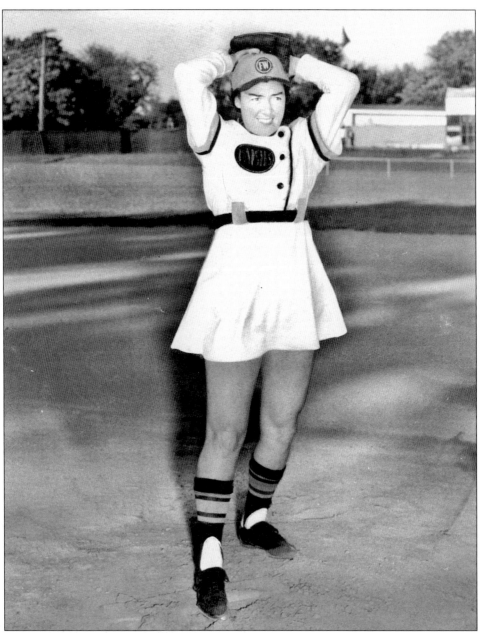

The thing Pat Scott remembers most about growing up on the family's farm on the north side of Burlington was that it had a baseball field where semi-pro teams played almost every weekend. The players took time to teach her to become a better player. In 1948, she traveled to Chicago to try out for the All-American Girls Professional Baseball League. At the end of a very long day of tryouts, Scott's name was among those posted on the team roster. She played for the team for only a short time until a family illness forced her to return home. In 1951, Pat returned to spring training with the Fort Wayne (Indiana) Daisies. She played with the team for three years, until leaving to study in Austria as an International Farm Youth exchange student. Pat is pictured here in 1951 in a Ft. Wayne Daisies uniform. She was inducted into the Baseball Hall of Fame in Cooperstown, New York, in 1989.

Five

FARMING
Farms, Farming, and Farm Families

Until quite recently, the economy of Burlington and the rest of Boone County was strongly rooted in agriculture. This late 1940s photograph of a man cultivating a tobacco field would have been a common sight at the time. In 1940, nearly 60 percent of Boone County residents lived on farms, and over 95 percent of the county was considered farmland. By 2000, only just over 1 percent of county residents were living on farms, and farmland made up only about half of the acreage in the county. (Photograph by Frank S. Milburn.)

Members of the Boitman family pause to have their picture taken in this World War II–era photograph. To the left is the horse-drawn wheat drill, and to the right is the family tractor purchased from Calvin Cress and Sons. Thanks to war-time rationing and shortages, farmers used their older horse-powered vehicles alongside their tractors. This tractor was one of the last sold by the Cresses before production in the war effort cut off their source of new tractors. Because of the short supply of rubber, the tractor is fitted with steel wheels.

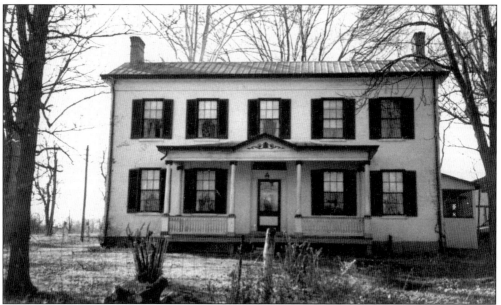

The Collins-Revill House was built in the 1840s for William Collins and is a blend of Federal and Greek Revival styles. In 1885, the house was purchased by Joseph C. Revill, one of the founders of the Boone County Deposit Bank. Located on Bullittsville Road just north of Burlington, the house became home to the Boitman family on September 6, 1940. At that time, the family still used coal-oil lamps, as the house had not yet been wired for electricity.

Three generations of a Burlington family stand in the yard behind the present-day Renaker Building. Young Albert Weaver stands in front of his parents, Nora and Lloyd Weaver, who was a candidate for circuit court clerk in 1933. On the left are Albert's grandparents, Laura and W.P. Beemon. The Weaver home was across the street from the old courthouse in the present-day Kentucky Farm Bureau office complex. Courthouse workers and others in Burlington could purchase dinner, served "family style," in the Weaver dining room.

The caption under this picture reads "Us kids and Freda Ryle—Harold's 8th Birthday." The picture was taken at the Williams Farm House in 1930. Pictured from left to right are Harold Williams, Glenrose Williams, Freda Ryle, and Osceola Williams. The farm's old tool shed is partially seen behind the house. The smoke house is more visible. As seen in the picture, cats and dogs were very common around the farm.

Although he grew up and lived near Hopeful Lutheran Church, Lester Fisher was one of many African Americans who worked on the farms that once lined Burlington Pike between Florence and Burlington. Until the mid-20th century, the Burlington area economy was based largely on agriculture. Before the Civil War, one in five Boone County residents was African American, and much of the farm labor on larger farms was accomplished by enslaved African Americans.

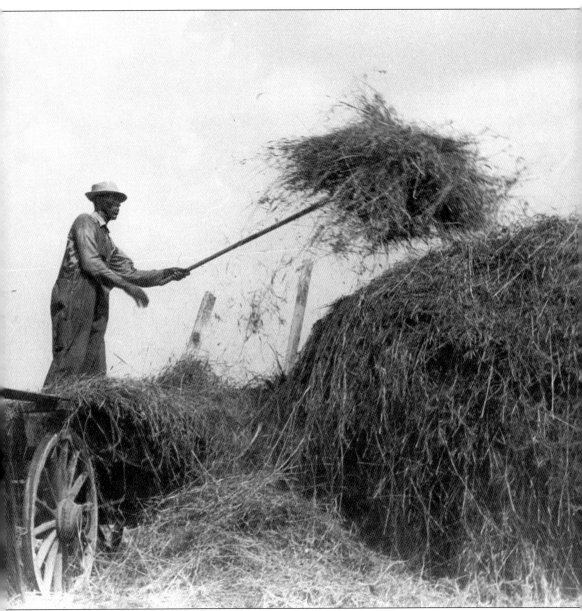

After the Civil War, the African-American population in Boone County dwindled to a few hundred individuals, although a small population remained in the Burlington area. These residents established both a Universalist church and the First Baptist Church of Burlington. The tiny congregation of the First Baptist still meets every Sunday. (Photograph by Frank S. Milburn.)

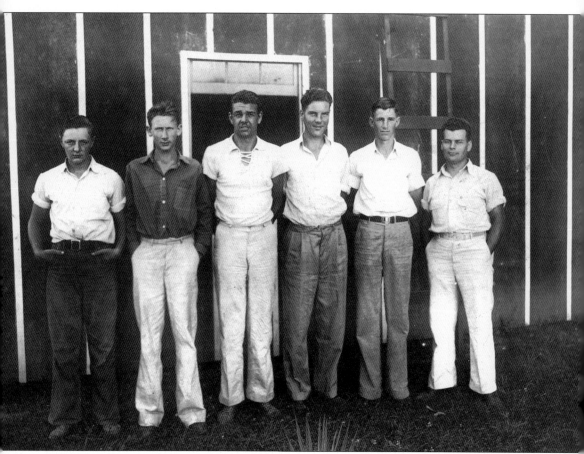

Shown here are members of the Future Farmers of America (FFA) Club at Hebron School, which was the first FFA Club in Boone County. A national FFA organization was founded in Kansas City in 1928 and grew steadily in popularity throughout the Depression. The FFA focuses on agricultural topics and hands-on supervised career experiences, provides leadership opportunities, and challenges students' agricultural skills. Pictured from left to right are Lewis Hossman, Lehman Hollis, John Randell, H.R. Williams, Bob Grant, and Jimmy Huey. The picture was taken in Hardingsburg, Kentucky, at an FFA camp in the summer of 1939. Bill Graves served as the first president of the club.

Eli Williams and his son Harold sit by the silo on the family farm. Both are snug in their winter clothes in this December 1924 photo. The silo attached to the farm's red barn was used to store corn. Eli and his father are sitting on a large wooden sled that was used to take bags of corn to the cattle.

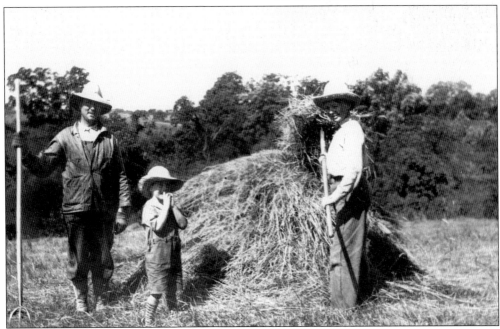

Photographed in 1927, Eli Williams pauses on his farm during the process of making hay shocks. Making hay shocks was an important event and often involved many family members and neighbors. The hay shocks were typically left outside for the cattle or pulled into a barn by horses or by other means.

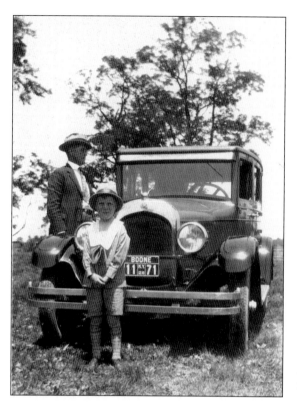

In this 1928 photograph, Eli Penn Williams and his son Harold proudly display the family's new Chrysler. Taken in 1928, the car was bought from a dealership on Dixie Highway in Devon. As was customary, both father and son are dressed because they were either going to Sunday church or visiting somebody.

Pausing to have his picture taken while sitting on a wheelbarrow, this farmer holds his Bible. Many of the residents of the Burlington area made their living from farming. Working the land six days a week, early residents set Sundays aside for rest and attending church. Denominations in Burlington have included Baptist, Methodist, Presbyterian, and Universalist congregations.

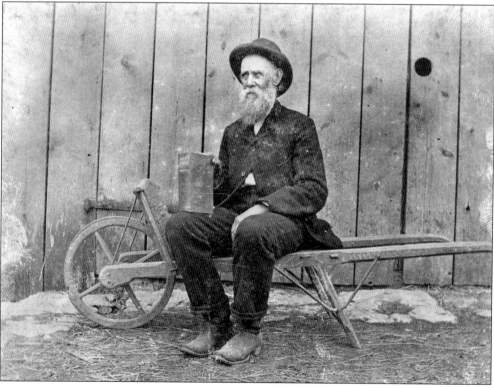

In this spring 1927 photo, Harold Williams
proudly shows off the toy Chrysler he received
the previous Christmas. It received far better gas
mileage than the Chrysler his father bought the
following year.

For farmers in Boone County, tobacco was an
important and widely-grown cash crop. Late
summer invariably saw the cutting and hanging
of the year's tobacco crop. In this picture, dated
August 30, 1962, Ben Boitman is helping to hang
the tobacco on the family farm on Bullittsville
Road. The tobacco would hang in the barn until
late fall when the leaves would be stripped from
the stalk and taken to market for sale.

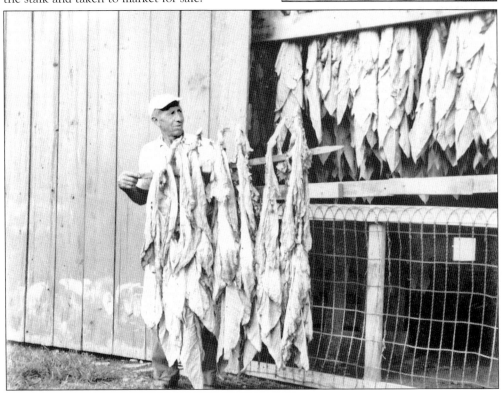

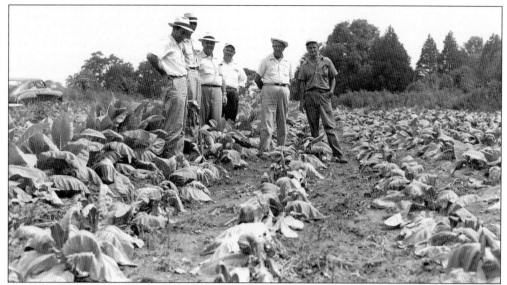

In this 1950s photograph, a team from the Boone County Conservation District inspects a tobacco field. Pictured from left to right are three unidentified people, Bob Ellis, Tom Ford, and M.L. Black. Organized in 1942, the Boone County Conservation District works closely with the United States Natural Resources Conservation Service, which was initiated in the late 1930s in response to the Great Dustbowl. For more than 60 years, the conservation district has helped farmers reduce soil erosion and maintain and improve the productivity of farmland and forests.

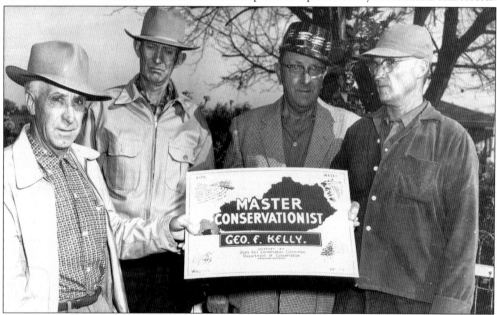

Boone County farmer George F. Kelly is recognized as a master conservationist in this mid-1950s photograph. Pictured are, from left to right, Steve Durr (of Kenton County), M.L. Black (supervisor), Tom Ford (Soil Conservation Service), and Mr. Kelly. The master conservationist program is still active in some Kentucky counties. To qualify, a farmer must implement at least 90 percent of a conservation farm plan developed in partnership with the county conservation district.

106

Located on East Bend Road about two miles from Burlington, the White Farm has been in the Maurer family since about 1875. As a long-time sheep farm, the property was designated a Kentucky Centennial Farm in 1992. Originally built as a one-story, hall-and-parlor dwelling in the late 19th century, the house was enlarged in 1917 when the two-story front block was added.

The White Farm includes an outstanding collection of historic farm buildings, including a two-level summer kitchen, root cellar, smokehouse, and one of the few remaining 19th-century drive-through corncribs in Boone County. The "Smiley Face Barn," which stands across the road from the main house, has become a well-known Burlington landmark. Farm owner Betsy Maurer Ligon and her son Robert added smiley faces on either side of the barn while painting the building in 1983. According to Betsy, everyone passing by that day had a scowl on their face, and she just wanted to cheer them up.

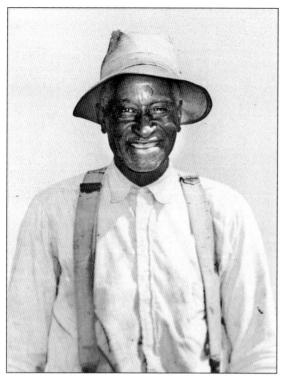

In the late 1940s, Frank S. Milburn photographed a number of farmers who lived in and around Burlington. Burlington farmer Stant Kirtley was photographed in September 1947. Kirtley was a well-known local who lived in a log house off Rogers Lane just south of Burlington. He farmed a small piece of bottom land along Allen Fork between East Bend Road and Rogers Lane. Kirtley owned a big team of horses that were available for hire. (Photograph by Frank S. Milburn.)

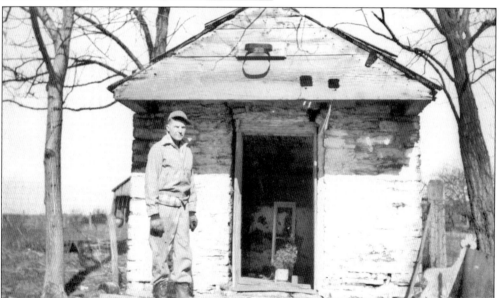

In this c. 1960 picture, long-time Burlington attorney John McEvoy stands in front of the slave quarters on the Duncan Farm, located about two miles outside Burlington on Idlewild Road. The small outbuilding sits behind the c. 1840 main house on the farm, which was assembled in the 1820s and 1830s by prosperous farmer John Duncan. Seven enslaved African Americans lived on the property in 1860. There is evidence that wooden bars once spanned the small windows of the slave quarters. The building is one of the few tangible remains of Burlington's antebellum past, when most wealthy landholders owned at least one slave.

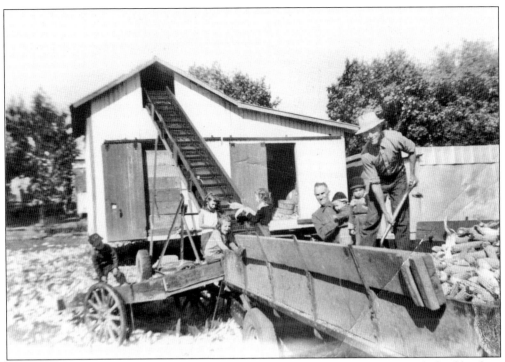

Farming was often a family affair. Here, brothers Gregor and Alois Boitman are helped by their nieces and nephews as they put the year's corn harvest into the corn crib. The Poole children are, from left to right, Michael, Michelle, Mildred, Rosemary, Martin, and Mark.

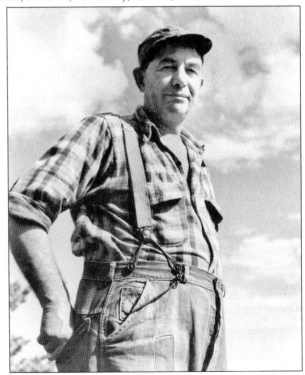

Frank S. Milburn experimented with innovative photographic and development techniques, including macro, early color-process photography, and infrared. In addition to landscapes and portraits, Milburn took amazing macro images of insects, bees, and snakes. Many of Milburn's photographic subjects appear larger than life, like this unidentified Burlington farmer who posed for Frank's camera in the late 1940s. (Photograph by Frank S. Milburn.)

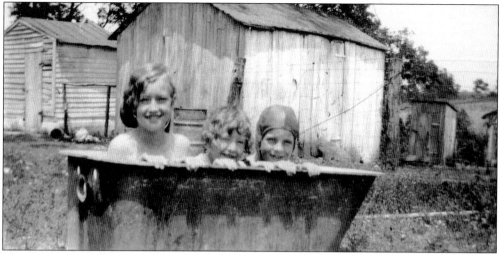

This picture was taken in 1930 on the Williams brothers farm near Bullittsville. Pictured from left to right are Glenrose "Glennie," Osceola "Ossie," and Harold "Bucky" Williams. The kids are playing in a bathtub, although it was not to be used for bathing. This farm had many springs on the sides of hills, and the cows would go to the springs for water, but their trampling hooves caused the springs to dam. Therefore, this tub was placed downhill near the cattle, and a pipe ran from the springs. The cattle then went to the tub instead of the springs. Bathing was done in the springs.

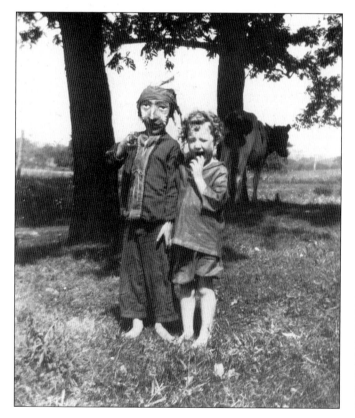

In this summer 1928 photo, Harold Williams wears his "Indian" costume that includes a false face. With him is his sister Osceola. In the background, one of the farm's milk cows is seeking shade under a tree.

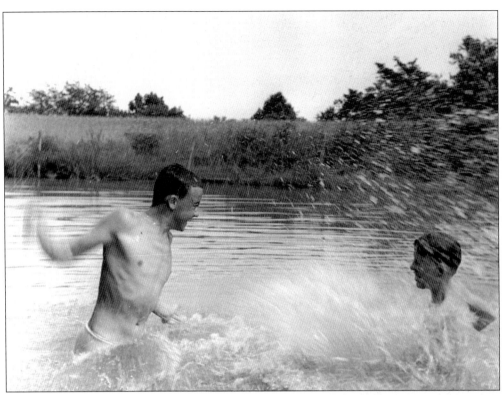

The pond on the Boitman Farm (Collins-Revill House) on Bullittsville Road was the most popular local swimming hole for Burlington teens. It was the perfect place for a cool dip in the middle of a blazing Ohio Valley summer. These c. 1955 pictures show Peter Cropper and Ralph McFarland (also shown in the portrait) in the midst of a water fight in the pond. (Photographs by Frank S. Milburn.)

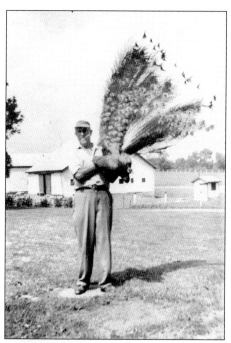

Aloysius Boitman holds one of his prized peacocks raised on the Collins-Revill Farm on Bullittsville Road. At night, the peacocks would be locked in their house to protect them from weasels and other predators. Each evening Mr. Boitman would whistle for the peafowl and offer them buttered bread to get them into their house. The cry of the peacock can be startling to a person who is not familiar with the sound. On one occasion, a neighbor hearing the cry thought someone was calling for help and called the county sheriff's office. After the sheriff's deputies arrived, the peacock, as if on cue, cried again and luckily helped convince the officers that no one was in trouble.

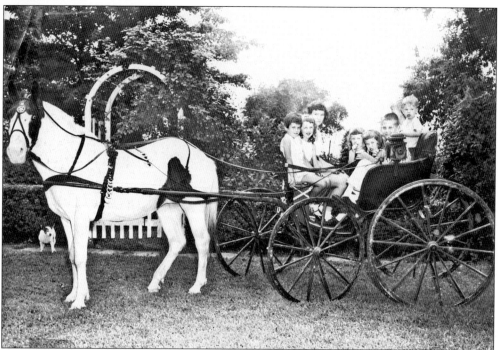

When the French Bauer Dairy switched from horse-drawn wagons to trucks, Aloysius Boitman was hired to clean out the company's garage of horse-drawn vehicles. For the price of $5, he became the owner of the carriage pictured here. Seen here in the carriage, from left to right, are Marcia Stoddard, Rosemary Poole, Michelle Wild, Michelle Poole, Mildred Poole, Steven Stoddard, Mike Poole, and Mark Poole. Also posing for the camera is Minnie, the family pony, while Mitzi, the family dog, looks on.

Six
NEARBY COMMUNITIES
Limaburg, Idlewild, and Middle Creek

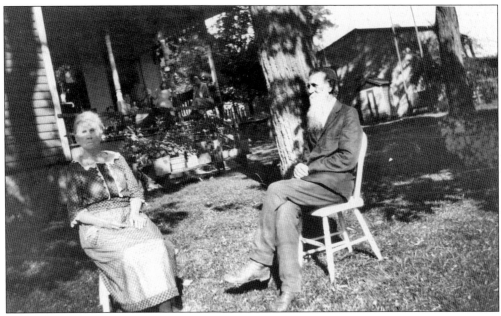

Thomas Zane Roberts is shown here *c.* 1920 sitting with an unidentified woman on the front lawn of his Middle Creek home. Described as a "rural genius," T.Z. Roberts was a teacher, preacher, farmer, miller, astronomer, poet, master carpenter, and gifted inventor. His house, located about two miles from the Dinsmore Homestead, incorporated many of his unique inventions, including suspended ceilings, a swinging bed, and fold-away walls. However, Roberts is known best for his monumental "Celestial Clock of Middle Creek."

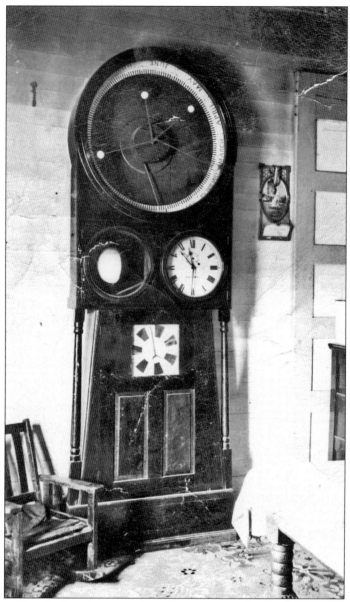

In 1909, Thomas Zane Roberts began work on the invention that has become synonymous with his life: the Celestial Clock. The notion that Roberts studied the planets for a year and secretly built the clock so that he would never again forget that it was Sunday and miss church is a myth. In fact, Roberts began working with clocks in 1882, and the only time he ever forgot about Sunday church was in 1883. Based on a modified eight-day Seth Thomas clock movement, the 7.5-foot-high Celestial Clock contains a standard clock dial, a calendar, a moonphase disc, and a planetarium. The planetarium is a miniature solar system with the sun surrounded by Venus, Earth, Mars, and Jupiter. The orbit of each planet is precisely geared: while Venus gains 1 degree of arc in 1,656 days, Jupiter loses 1 degree of arc on 250 years. The clock has never been opened so the true nature of Roberts's invention remains somewhat of a mystery. Today, the clock is located in the lobby of the Heritage Bank on Burlington Pike. It is still running and keeping time, 80 years after the death of its inventor.

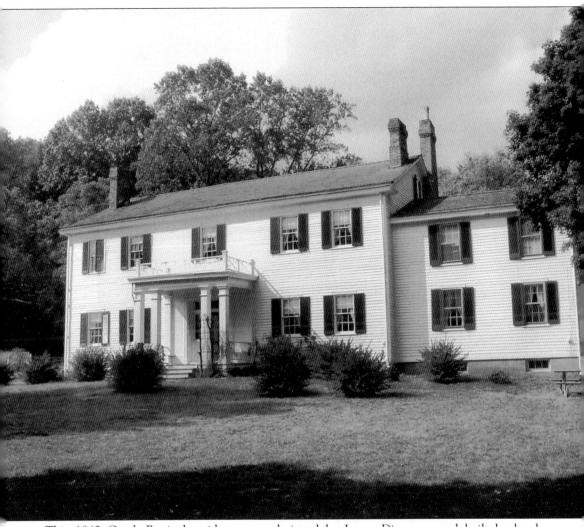

This 1842 Greek Revival residence was designed by James Dinsmore and built by local men. Over the next 150 years, five generations of the Dinsmore family lived and visited here, leaving behind their furniture, books, correspondence, and personal artifacts. Today, the Dinsmore Homestead, including 80 acres of trails, the main house, several outbuildings, and the family cemetery, is open for tours. Area teachers and school children enjoy their popular education program, which promotes a greater awareness of Kentucky heritage and Ohio River Valley history.

Julia Stockton Dinsmore poses on her favorite horse, Kitty, in front of her family home. In 1872, at the age of 39, she inherited the 400-acre family farm from her father, James. She managed the farm for the next 54 years, while raising the two daughters of her deceased sister. "Miss Julia" was responsible for creating the protective and loving atmosphere of the homestead that brought future generations back so often. This picture was taken around 1895, at a time when Julia was writing poetry for publication in the New Orleans *Times-Democrat*.

Patty Selmes (granddaughter of James Dinsmore) is pictured standing with Corinne Roosevelt Robinson (sister to Theodore Roosevelt) below an aged tulip poplar tree near the family cemetery at the Dinsmore Homestead, *c.* 1900. Wearing a white dress, Mrs. Robinson is almost invisible next to the giant tree.

This picture was taken in the spring of 1916 when Julia Dinsmore was 83 years old. Martha Ferguson is the young girl, and this was her first visit to Kentucky from her home in New Mexico. Although two generations separated Miss Julia from her great-great-niece Martha, the resemblance between the two is remarkable. Martha (married name Breasted), the daughter of Isabella Selmes and her first husband, Robert Munro Ferguson, was the last descendant of James Dinsmore to own the farm.

Taken in 1902 when Isabella Selmes Greenway was 16 years old, this picture shows Isabella in the bloom of youth. A capable artist, she was the daughter of Martha Macomb Flandrau and her husband, Tilden Selmes. From the time of her birth, Isabella spent her summers with her great-aunt Julia Dinsmore at the family farm. While attending finishing school in New York City, she befriended Eleanor Roosevelt, and they remained lifelong correspondents. Isabella married three times, had three children, and was the first congresswoman elected from the state of Arizona.

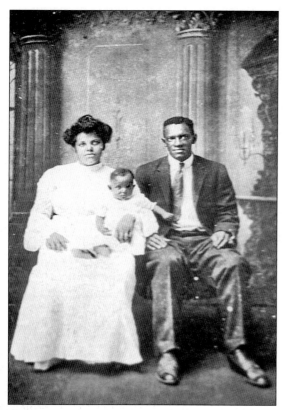

This c. 1906 family picture shows Harry and Sussie Roseberry and their eldest daughter, Cleo. Harry was born in Boone County, perhaps in Petersburg, and began working for Julia Dinsmore in the 1890s when he was only 14 years old. He lived in a tenant house on the property, married, and eventually had four daughters and numerous grandchildren. Harry Roseberry is appreciated for protecting the Dinsmore property while no family members lived there. In the 1960s, Harry's daughter moved him to a nursing home, where he died a short while later.

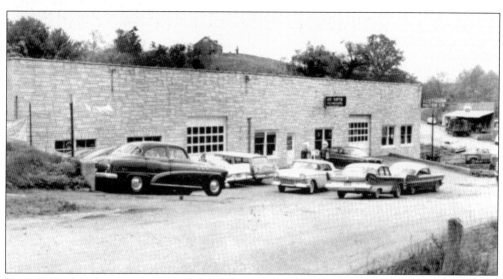

From 1959, this photograph shows the Scothorn Motor Company in Idlewild. Originally called Gainesville, after the large and influential Gaines family who owned much of the surrounding land, Idlewild grew up at the junction of the Burlington-Petersburg Turnpike (presently Route 20) and Ashby Fork. Like most of the small communities outside Burlington, the village once offered a range of services and a general store. Today, Carroll's Auto Service in the old Scothorn building is the only business in Idlewild.

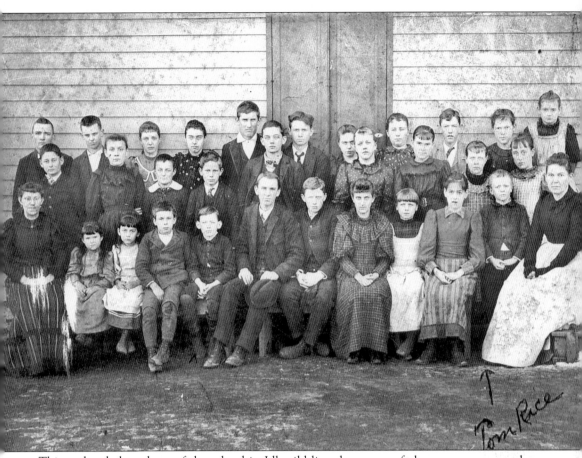

This undated class photo of the school in Idlewild lists the names of almost everyone on the back of the picture. Shown are, from left to right, (front row) Ms. Mabel Kirtley, two unidentified children, Chester Rice, Kenneth Balsley, Chester Gaines, Lewis Gaines, "Dink" Scothorn, Sophia Ackelmeyer, Ethel Terrill, Tom Rice, and Mrs. Fannie Kirtley (teacher); (middle row) Lyman Gaines, Bess Gaines, Dan Gaines, Jack Henry, Edgar Graves, Bess Stevens, Lacy Kirtley, Bess Cropper, and Nell Duncan; (back row) George Terrill, Marshall Terrill, Fannie Stevens, Alberta Gaines, Luther Scothorn, "Hack" Walton, Etta Mae Graves, Fannie Willis, Felix Gaines, Sadie Kirtley, and Amanda (or Alta) Terrill. Today, the little white schoolhouse is a private residence.

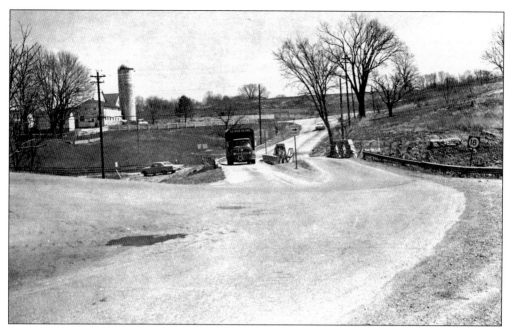

Before Burlington Pike was widened in 1974, the route from Florence to Burlington was a narrow two-lane country road. For many years, the Limaburg Creek Bridge was a single lane, and the bridge was the site of many accidents. A second lane was added about 1970, just a few years before the new four-lane Burlington Pike was completed. Some segments of old Burlington Pike survive, including the stretch shown in the upper picture running in front of J's Acres Farms, now called Limaburg Creek Road. The lower photograph was taken from a point that now lies near the entrance to the Burger King restaurant on Burlington Pike. The silo at J's Acres and the barn on the far hillside are two landmarks that remain along this otherwise dramatically altered transportation corridor. (Photographs by Frank S. Milburn, April 1972.)

Seven

NEW INVESTMENT IN OLD BURLINGTON

A Growing Community

Linda Whittenburg sits on the porch of the log cabin that she and her husband, Dan, restored as Cabin Arts of Burlington. Known locally as the Hogan House, the building is one of several log structures on North Jefferson Street that was once part of the Willis Graves estate. Originally built as tenant housing in the 1850s, the cabin is named after James Hogan, who owned it from 1881 to 1912. The Whittenburgs restored the cabin and opened the business in 1992. Linda began offering quilting classes in 1996.

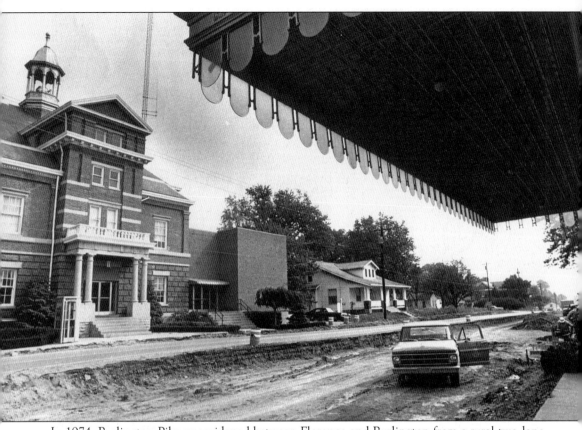

In 1974, Burlington Pike was widened between Florence and Burlington from a rural two-lane route into a four-lane divided highway. That expansion helped usher in a building boom that has dramatically changed rural Burlington in the past two decades. Between 1990 and 2003, the population of the Burlington area nearly doubled. Along the road to Florence, farms have been replaced by retail development and subdivisions, and evening traffic coming into Burlington is routinely congested. Despite the rapid growth, the 1889 courthouse and numerous 19th- and early 20th-century buildings continue to keep Burlington a "historic" community. (Photograph by *Kentucky Post* photographer ? Pridemore, courtesy Kenton County Public Library.)

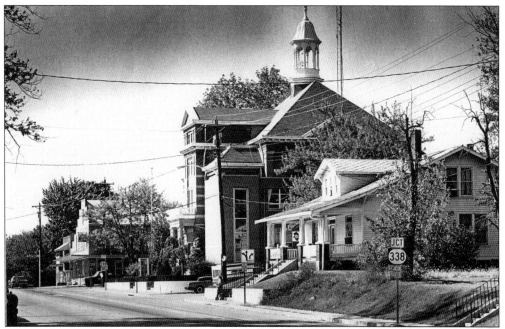

Looking west on Burlington Pike, the 1889 Boone County Courthouse is seen in this 1974 photo, along with a bungalow that was demolished in 1981. That site is now occupied by a small white gazebo that has been the scene of many impromptu wedding pictures. (Photograph by *Kentucky Post* photographer ? Pridemore, courtesy Kenton County Public Library.)

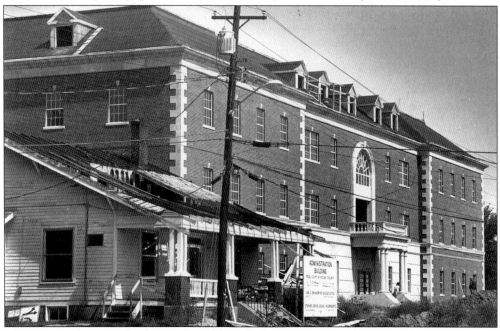

This 1981 photograph shows the old and the new in Burlington. The new county Administration Building is under construction while the bungalow sitting on the adjacent property is slowly being dismantled. (Photograph by *Kentucky Post* photographer Jim Osborne, courtesy Kenton County Public Library.)

Wilford Fleek holds the Medal of Honor awarded to his son Charles Clinton Fleek, known locally as "Chalkie," on November 29, 1981 at the dedication of the Boone County Administration Building, which was dedicated to Charles Fleek. The plaque reads, "Sergeant Charles C. Fleek distinguished himself by serving as a squad leader . . . where on May 27, 1967, during an ambush operation in Binh Duong Province, Republic of Vietnam, an enemy soldier threw a grenade into the squad position. Realizing that his men had not seen the grenade, Sergeant Fleek, although in a position to take cover, shouted a warning to his comrades and threw himself onto the grenade, absorbing its blast." Fleek's actions that day saved the lives of at least eight of his fellow soldiers. Fleek's heroic action was well publicized and brought the grim reality of the Vietnam War to the heart of Boone County. (Photograph by *Kentucky Post* photographer Jim Osborn, courtesy Kenton County Public Library.)

The Boone County Administration Building was dedicated on November 29, 1981. In this photo, former Kentucky governor and U.S. Sen. Wendell Ford addresses the crowd on dedication day. Seated to Senator Ford's right is the Fleek family. Seated to his immediate left is Boone County commissioner and future U.S. Congressman, Ken Lucas. Lucas also served as Boone County judge-executive. (Photograph by *Kentucky Post* photographer Jim Osborne, courtesy Kenton County Public Library.)

This December 1974 photograph shows local artist Mary Amanda Moore putting the finishing touches on the seal of the Commonwealth of Kentucky. To the right is her painting of the state bird, the Kentucky cardinal. Both paintings still hang behind the judge's bench in the second-floor court room of the courthouse. Among Moore's many paintings were the portraits of Boone County soldiers killed in the Vietnam War, presented to their families on Memorial Day Weekend in 1972. (Photograph by *Kentucky Post* photographer Joseph C. Ruh, courtesy Kenton County Public Library.)

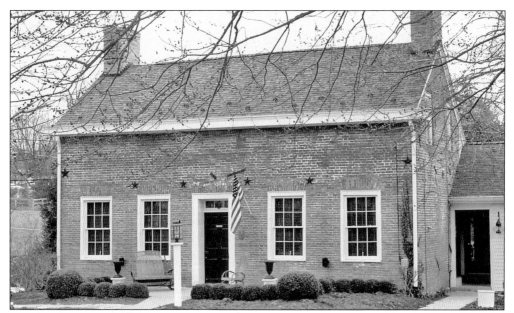

The *c.* 1830 Willis Graves House is located next to the fairgrounds and anchors the northwest corner of Burlington's historic street grid. The house was built by Willis Graves, who served as Boone County clerk during the 1810s and 1820s. It is one of several Federal-style, brick dwellings in Burlington and features Flemish-bond brickwork and brick-jack arches over the windows and doors.

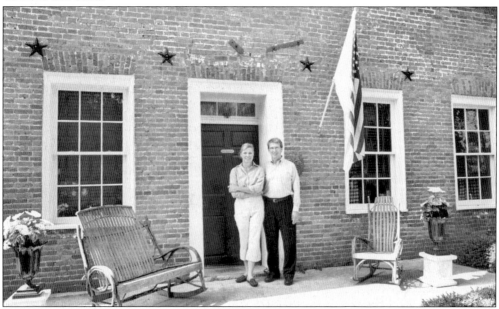

In the 1980s, Nancy and Bob Swartzel frequented the monthly Burlington Antique Show at the Boone County Fairgrounds. The Swartzels bought the Willis Graves House in 1991 and began operating an antique shop in the older part of the building. After a great deal of investment, the couple opened Burlington's Willis Graves Bed & Breakfast in 1995. The business has grown ever since. In 2004, the *c.* 1855 William A. Rouse log house was moved to the back of the property and restored for use as two additional guest suites.

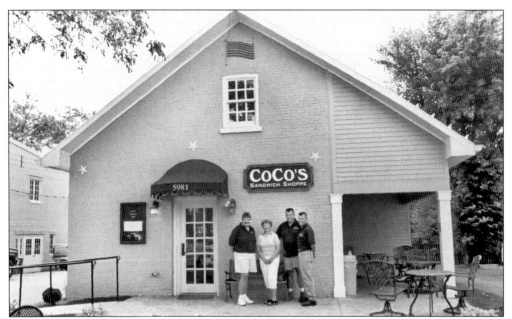

In 2002, the Joseph Graves House on Union Square was rehabilitated and converted into CoCo's Sandwich Shoppe by the Roscoe Group, L.L.C., who posed for this picture. Shown here, from left to right, are Shelli Allen, Arlene Jones, Brad Jones, and Casey Jones. The Graves House was built to face north, away from Union Square, and may date to as early as 1817. Descendants of Pete Stephens, the Roscoe Group converted Burlington Hardware into the County Seat Restaurant in 2003 and moved CoCo's Sandwiche Shoppe into the north end of the building in mid-2004.

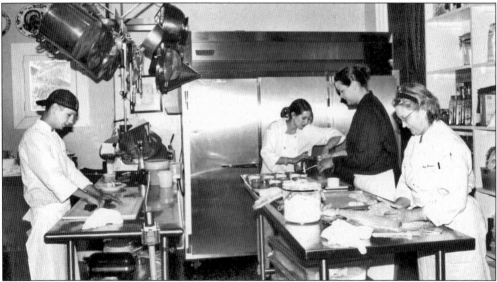

The latest business to occupy the c. 1822 Erastus Tousey House is the Tousey House Restaurant. Chef-owner Kristy Schalck and her husband, Dan, bought the property from former Boone County judge-executive Bruce Ferguson in 1998 and converted it into the restaurant, which opened in 2001. Pictured here in the kitchen are, from left to right, sous chef Patrick Kenyon, pantry chef Sara Reaves, sous chef Shannon Sullivan, and executive chef Kristy Schalck.

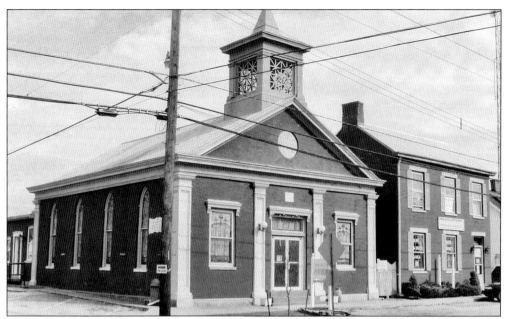

The Burlington Methodist Episcopal Church was established in 1835, and the congregation completed a house of worship on North Jefferson Street in 1837. Originally built in the Greek Revival style, the church building was completely remodeled in 1923 in a late Gothic Revival style. Known locally as the Sallee House, the adjacent Greek Revival building may have been built by James Runyan as early as 1840. At one time, it was the church parsonage, but it has housed various businesses over the past few years.

Betty Sallee and her husband, Charles, bought the 1837 Burlington Methodist Church and adjacent brick house in 1992. The brick house next to the church was in such poor condition that the owners included it in the sale of the church. The Sallees completely rebuilt the collapsing back wall of the house and converted the church into an antique shop. Shown sitting in a rocking chair in the church sanctuary, Betty Sallee has been the proprietor of Burlington Antiques ever since.